BUCKNALL TO CELLARHEAD

THROUGH TIME

Neil Collingwood

For A)d

With Best wisyes

25TH JANuary 2019

AMBERLEY

Acknowledgements

I would like to thank Ash Bank Garage, Blake Morgan LLP, Claire Bennett, Mike Bloor, Sue Bloor, Alan Bourne, Gary Cosgrove, Debbie Date, David P. Daws, Mervyn Edwards, Barbara Fenton-Grocock, Paul Fenwick, Geoff & Jean Fisher, Alan 'Sketch' Fletcher, Sue Fox, Innovations (Bucknall), Interfinancial, Robert Hirst, Shirley Huntbach, Bill Jackson, John Jedlinski, Just For Kids (JFK) Werrington, Graham and Barbara Key, Kingsland Primary School, Vince Lane, Ian Lewis, Barbara Lister, Brian Lomax, The Ministry of Justice, Peter John Nixon, Alison Parish, (Charles) Geoff Perkin, St Philip's Church Werrington, Alf Forrester Ratcliff, The Red Cow, Werrington, Mr K Robateau, Dave & Megan Scrivens, Arthur Shirley, Brent and Claire Singleton, Arthur Shirley, Shirley's Transport Cellarhead, Jonathan Sides, Mrs Julia Smith, St Stephen's Community Church, Bentilee, Julie L. Thomas, The Travellers Rest, Bucknall, John Tunna, Stan Twigg, Werrington Young Offenders Institution, Angela Woolridge.

All the staff at Newcastle-under-Lyme Borough Museum and Staffordshire County Museum Service.

If anyone has been unintentionally missed from this list, please accept the author's apologies. With special thanks to C. H. (Harry) Burn and Councillor Jean Fryer of Werrington for making available some of the photographs collected by Elizabeth W. Bass and her late husband Jeff.

The photograph of The Brookhouse on Page 47 is published courtesy of Staffordshire County Record Office.

First published 2016

Amberley Publishing
The Hill, Stroud, Gloucestershire, GL5 4EP
www.amberley-books.com

Copyright © Neil Collingwood, 2016

The right of Neil Collingwood to be identified as the Author of this work has been asserted in accordance with the Copyrights, Designs and Patents Act 1988.

ISBN 978 1 4456 4760 9 (print)
ISBN 978 1 4456 4761 6 (ebook)

British Library Cataloguing in Publication Data.
A catalogue record for this book is available from the British Library.

Typesetting by Amberley Publishing.
Printed in Great Britain.

Introduction

With the exception of a few short detours on the way, *Bucknall to Cellarhead Through Time* follows the route of the busy A52 road, out of industrial Stoke-on-Trent and into the North Staffordshire countryside. The A52 actually begins in nearby Newcastle-under-Lyme and makes its way 147 miles eastwards to Mablethorpe, where it terminates only 100 yards or so from the North Sea. In this book though, the road is followed from Lime Kiln Bank, where it is called Bucknall Road, through Bucknall, where it is known as Werrington Road, and via Ash Bank Road to Werrington. Finally it continues onwards to Cellarhead, by which time it has become Cellarhead Road.

Bucknall, at the beginning of this 4-mile journey, is an ancient village, the only place covered in this volume that appeared in William the Conqueror's Domesday survey of 1086. In Domesday it appears as Bvchenole which is believed to be of Anglo-Saxon origin and meaning Bucca's Halh, a 'halh' being a remote valley. This suggests that the Trent Valley, where Bucknall Park is today, was the property of an Anglo-Saxon chieftain called Bucca. Later it became Buckenhall and finally Bucknall. There are however alternative theories suggested for the name's origin.

Despite having been in existence since before 1086 almost everything ancient, or even just 'very old' in Bucknall seems to have been swept away over the subsequent centuries, its churches, bridges, mills and old houses. The bridge over the River Trent is relatively recent, its church is Victorian and such old houses as remain are scattered throughout the district and probably seldom date from before the eighteenth century. One of the most interesting houses in the area, The Brookhouse (1636) which stood next to the road at the bottom of Ash Bank was dismantled in the early 1970s and transported to Knighton in Shropshire where it was rebuilt and still stands today (see front cover). Another historically interesting building that does still survive in Bucknall is Ford Hayes Farm, which was the birthplace and home for sixteen years of Hugh Bourne, joint founder of Primitive Methodism.

As with most sizeable villages there was, and still is, a church at Bucknall and the building that stands today is believed to be at least the third on the same site. The present one was built in 1856, the previous one in 1718 and before that there was at least one wooden-framed church there. The original village would have centred on the church and indeed photographs show a large house of uncertain date at the top of Church Lane (now Marychurch Road) and a thatched cottage at the bottom of that road until the early twentieth century. These have both since disappeared but the nearby Red Lion and Mason's Arms public houses on Ruxley Road may be of significant age.

A diversion to Ubberley reveals the site of an ancient stone-built gentleman's seat, Ubberley Hall, which may have been home to the de Verdon family, who later occupied Alton Castle. The (de) Verdon family were related to the Allens of Bucknall who may have been the same Allens responsible for building The Brookhouse, mentioned above. Sadly Ubberley Hall was demolished in the late 1950s to make way for council housing on the Bentilee Estate, which was at the time the largest housing estate in Europe.

Until the 1930s, leaving Bucknall via Ash Bank Road would have meant going into the countryside, as it was only in that period that the Ash Hall estate was broken up and houses

began to be built on both sides of the road. Prior to that there would have been a few isolated farms set well back off the road and only enough buildings next to it to count on one hand before reaching Werrington: Mettle House Farm, Ash House, the lodge to Ash Hall, the cottage at the end of Bridle Path and then the cottages at Werrington crossroads. There may have been a few other smaller buildings but these have not survived.

The next stop on the journey is Werrington, which was originally a small settlement concentrated around the windmill, which dates from *c.* 1730. There were a number of cottages clustered close to the mill and at least two pubs, the Windmill Inn and the Blue Ball. Werrington though has undergone a remarkable transformation in the past sixty-five years with large housing developments being erected in the 1950s and 1960s together with the facilities required to service them. This 'small village' now has a population of more than 5,500 people, complete with shops, a pub, a church, a village hall, a Methodist chapel, library, clinic and doctor's surgery, in fact virtually everything that might be required by the local people for everyday life. Like Bucknall, Werrington may be named for a town (township) ruled over by an Anglo-Saxon chieftain, Werra or Wherra but such suppositions are always difficult to prove.

Close to Werrington along Washerwall Lane was a separate small hamlet called Washerwall, believed to have acquired its name from the 'Wash Well', (later Washerwall) that is still in existence there. Washerwall had its own shops, a Methodist chapel and several wells but no public house. The hamlet stood at the edge of Wetley Moor, an area where quarrying of both building stone and high-quality sand took place. The major buildings of the area such as Ash Hall, Ash House and St Philip's Church were built using local materials which would have come from these, or similar quarries in the area.

The final place on our journey is Cellarhead, a small hamlet centred on the crossroads where the A52 crosses the A520, running from Leek to Stone. In the past it was a meeting-place where fairs were held and where a public house was opened on each corner: the Spotted Cow (later the Bowling Green), the Red Lion, the Hope & Anchor and the Royal Oak. The last of these to operate as a pub, the Bowling Green, closed in about 2009 and has been converted to a health centre. Cellarhead had its own Methodist chapel which closed not all that many years ago and a motor repair garage that stood on the A52 until its demolition in 2004. The chapel has since been used by several small businesses including a glass-maker and the site of the garage has been built on. Cellarhead is now somewhere that people either just pass through or where they go to visit the health centre or the filling station and shop at Shirley's transport.

It is hoped that this pictorial trip along the A52 will be both educational and enjoyable. Old photographs of the area have proved difficult to find, or to access, particularly those of the various pubs in Bucknall: the Red Lion, the White Lion, the Queen of Hearts, the Werrington Hotel, the Masons Arms and the Travellers Rest. It also proved impossible to acquire even one photo of one of the most important houses in the area, Ash House, opposite Ash Hall. This was transformed over time from a gentleman's residence to the Ash Bank Hotel frequented by celebrities performing at Stoke-on-Trent venues. Perhaps people studying this volume will realise that they have photos of Bucknall to Cellarhead that would be of great interest to others.

Neil Collingwood
January 2016

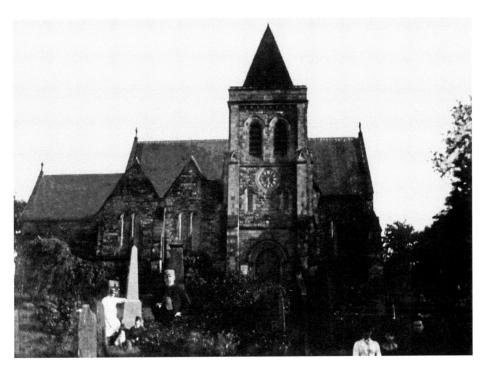

The Church of St Mary the Virgin, Church Road

There have been at least three churches on this site in Bucknall; the present church was built in 1856 replacing one of 1718, which apparently incorporated parts of the ruined Hulton Abbey. Sadly when the 1718 church was demolished these abbey fragments were lost. Prior to 1718 there is believed to have been an earlier, timber-framed church on the site. Job Meigh of Ash Hall (page 56) donated money towards building the existing church and he and his son were members of the congregation.

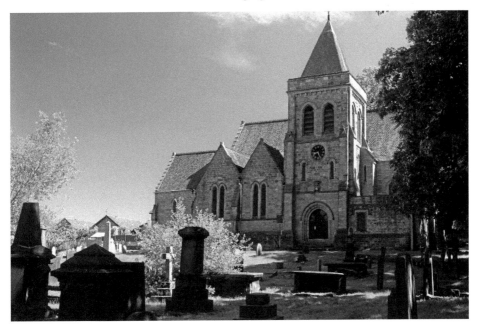

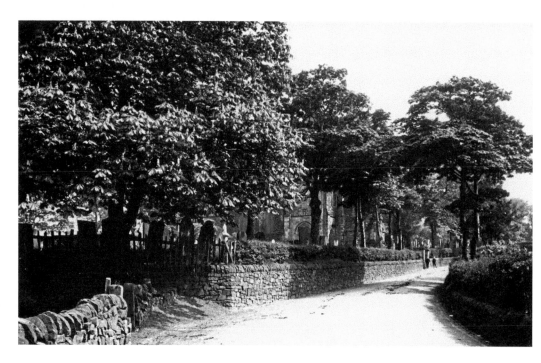

Church Road, from the bottom

In this *c.* 1910 photo Church Road, as it was then called, looks very rural but in fact was located close to the belching chimneys of the Stoke-on-Trent pottery industry. Today the line and width of the road have changed little and the trees along the edge of the churchyard still obscure the church in the summer. The most noticeable change is the presence of the building on the left, formerly a Co-op and now occupied by Trenton Construction Co. Ltd.

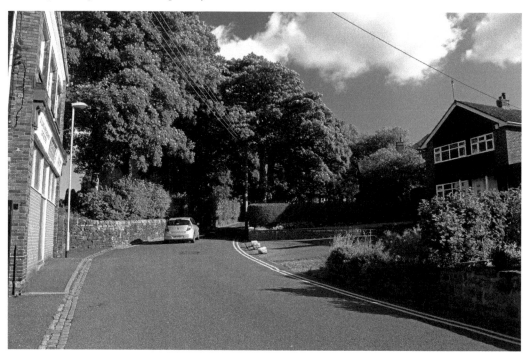

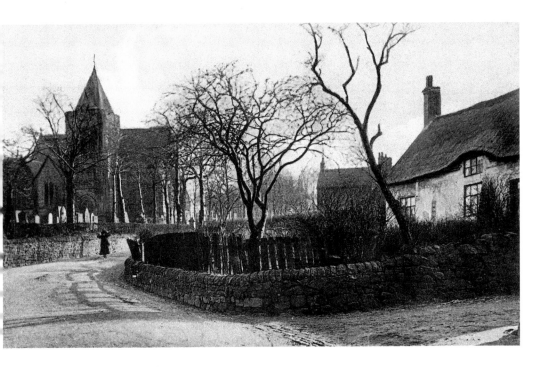

Church Road, from the bottom

The old photo, again from the bottom of Church Road, was taken in the winter, allowing the church to be seen through the bare trees. On the right is a picturesque thatched cottage and beyond it a house where the church car park is now. Just visible in the distance is Bucknall House (see page 8). Today, apart from the church, these buildings have all been demolished and there are houses most of the way up the right-hand side of the road.

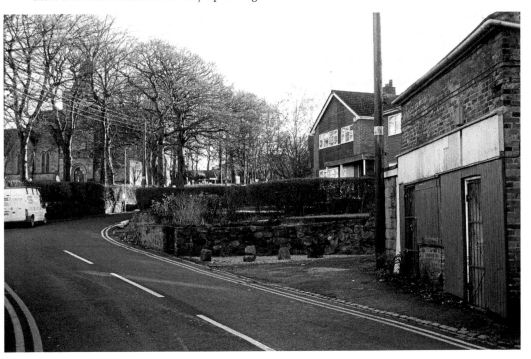

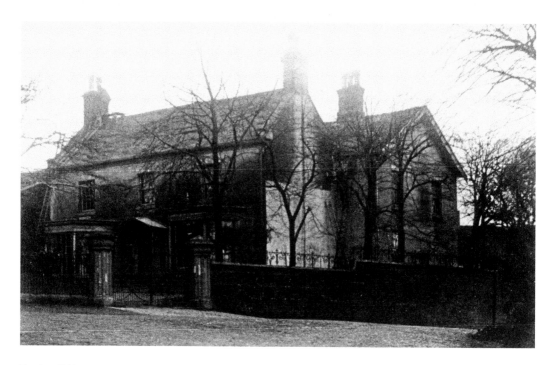

Bucknall House

The large house at the top of Church Lane probably merits a book in itself, as even what it was seems difficult to establish. It is variously referred to as Bucknall House, Bucknall Hall, 'The Big House' and St Mary's Rectory and was still in situ until around 1960. Apparently a condition in the deeds of the houses built on the site forbids them to brew alcohol because they were built on church land, lending credence to it having been the rectory at some time.

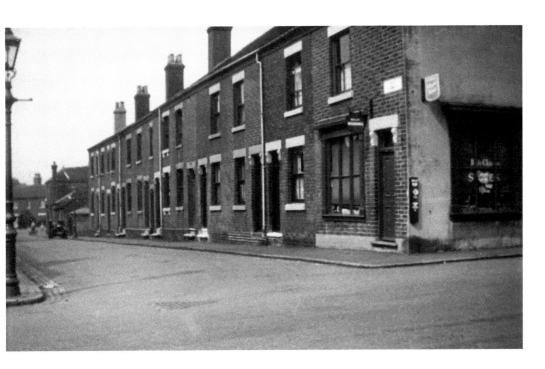

Guy Street from Ruxley Road, *c. 1957*

This street had only been Guy Street for three years when the old photo was taken, having originally been called been New Street. Guy Street is less altered than its near neighbour Pennel Street, in that it is still mostly lined by traditional terraced houses and has retained its corner shop. The customary enamelled signs attached to the shop, and often very valuable today, advertise 'Players Please' and 'Will's Woodbines' and on the corner is a chewing gum/bubble gum machine.

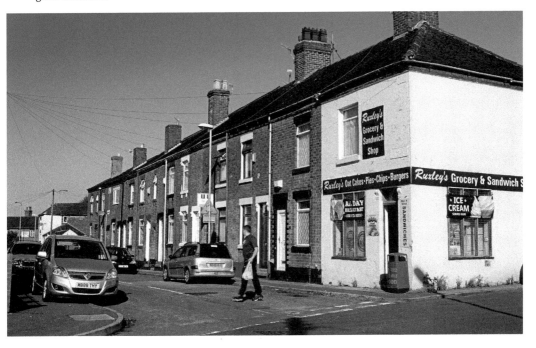

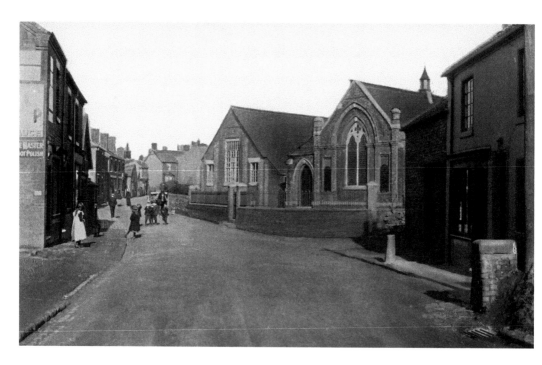

High Street Methodist Church and Sunday School, c. 1905

The old photo was taken from the middle of what was then High Street and shows Bucknall Wesleyan Chapel and Sunday school, since demolished, on the right. This postcard is an early example of photo manipulation; when examined closely, it can be seen that the sky has been lightened and that there is a grey border around every chimney and roof. This sort of work would be much easier to do today using a computer, and the finished result would be much better.

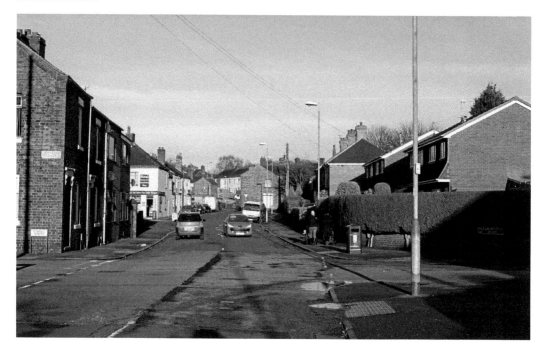

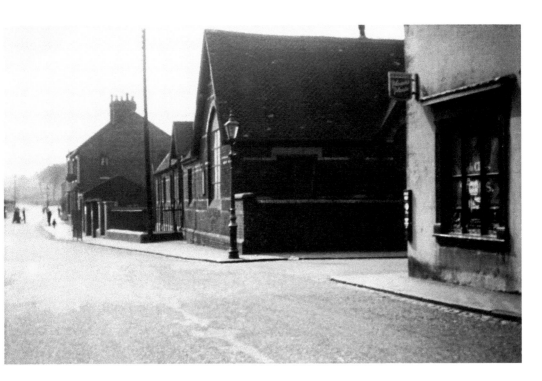

Ruxley Road and 'Guy Street' School, *c.* 1957

This pair of photos is looking along Ruxley Road towards Marychurch Road. On the right is the shop at the end of Guy Street (page 9) now Ruxley's Grocers & Sandwich Shop and beyond it Bucknall Church of England Junior School, known locally as 'Guy Street School'. After the school was demolished the site was used to build three detached houses (see new photo). Beyond the school is the block, still standing today, that ends on the corner of Pennel Street.

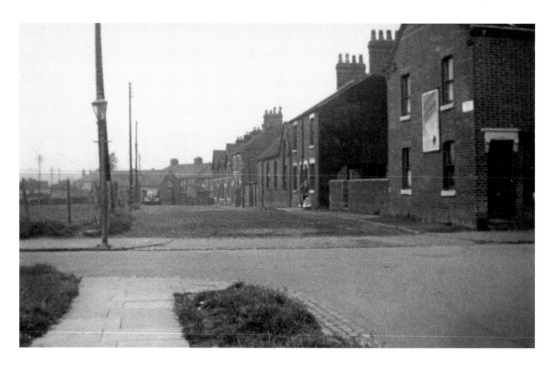

End of Pennel Street from Corneville Road, *c. 1957*

In the old photo, Pennel Street seems not yet to have been tarmacked and to the left is a field, possibly part of Bucknall Farm, which was located near the top of Marychurch Road. The large building on the left with a lorry in the distance outside is the building that Scragg's Coaches operated from until their move to Park Hall Road. Bungalows now line Mary Rose Close, in the former field, and all the way along Ruxley Road to the former farmyard.

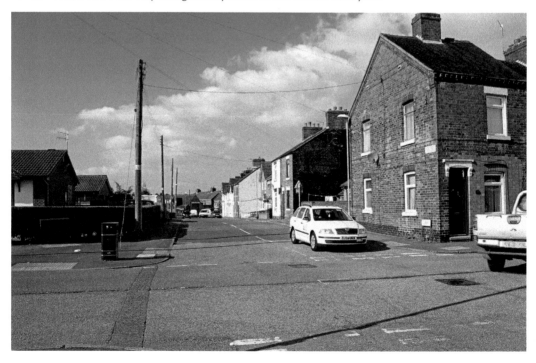

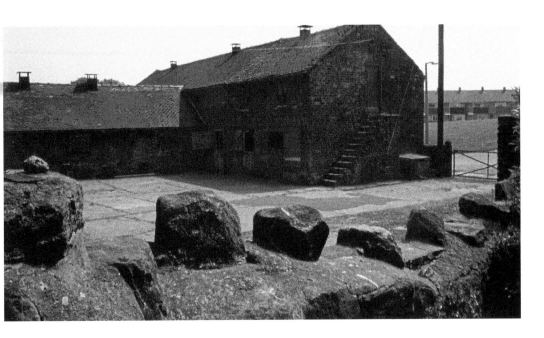

Bucknall Farm

This farm was located on Ruxley Road near to Marychurch Road. The farmhouse, still bearing the name 'Bucknall Farm' on the gate and with a date stone of 1935 survives but the outbuildings have been demolished and the fields built over (see previous caption). The farmyard, shown here has now been replaced by a housing development called Runnymede Close. In the distance, is a grassed area and a row of houses on Westfield Road occupying the former site of a slag heap.

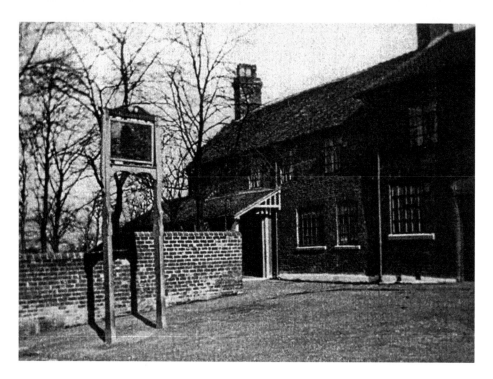

The Red Lion, Ruxley Road

This rather poor photo of the Red Lion on Ruxley Road, is one of only two that could be located and the second one was even worse than this. As with many pubs there used to be a bowling green at the side, now converted into a car park. There is a question over the future of this ancient pub, which has changed hands repeatedly in recent years and it can only be hoped that it will survive.

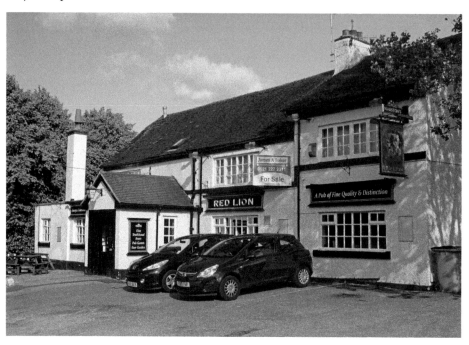

Ruxley Road/High Street with Flint Mill, *c.* 1957

This old photo shows the view up Ruxley Road from near its junction with Werrington Road – now blocked off. On the left is the former Edward's Flint Mill, the site of which is now occupied by Staffordshire Housing Association's Ruxley Court complex. On the right can be seen the Masons Arms advertising Ind Coope's Double Diamond beer. In the distance can be seen Chapel Terrace and beyond it the Methodist Chapel, since demolished, that gave the terrace its name.

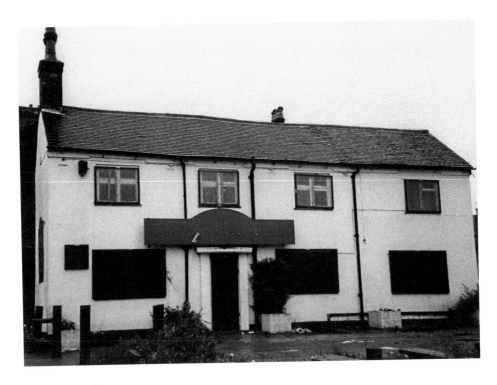

The Masons Arms

This photo of the Masons Arms in Ruxley Road was taken soon after it closed. It used to have a sign on the side bearing images relating to the Worshipful Company of Stonemasons, (not the same as the Freemasons), including their motto 'God is our guide'. The pub reopened for a short time as The Old Iron Cot but then closed again and was converted into a house. At the time of writing it is up for sale once again.

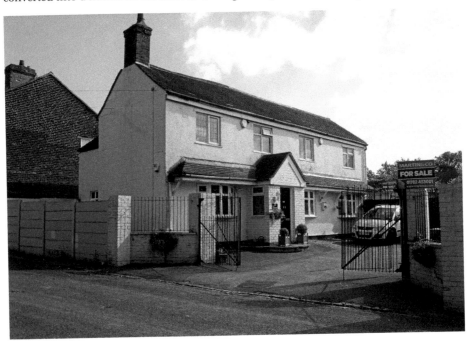

Wooliscroft Road, c. 1957

Wooliscroft Road today is lined by council bungalows on one side and council British Iron & Steel Federation (BISF) houses on the other. The bungalows were built on what was originally a slag heap (see page 19) and later the site of pre-fabricated bungalows (as shown here). The BISF houses, which used to have corrugated metal cladding on their elevations, have now been upgraded to greatly improve their energy efficiency. The total absence of traffic or parked cars is notable, very different from today.

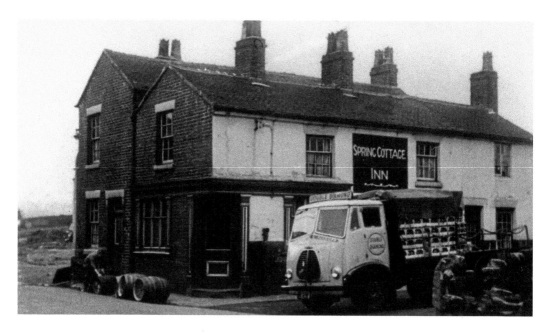

Twigg Street, The Spring Cottage Inn, 1950s

Until 1954 Twigg Street was called James Street. Today Twigg Street has a row of shops on one side but there used to be a row of houses attached to these, with a corner shop (see next page). Across the road, where the trees are now, stood the Spring Cottage Inn. It is believed that this photo was taken because it showed the draymen, in their Scammel lorry, collecting the kegs and bottles from the pub for the last time.

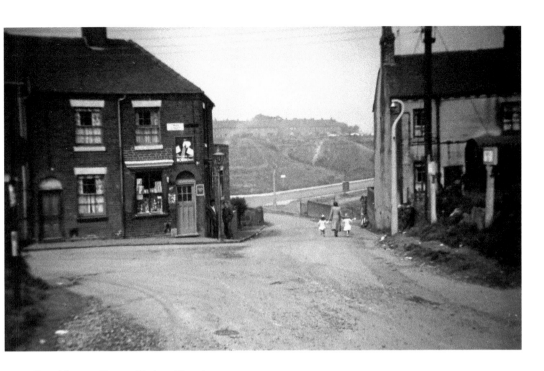

Brookhouse Green, Twigg Street, c. 1957

This old photo shows Boulton's corner shop and the Bourne family's house formerly attached to the surviving shops on Twigg Street. In the background, beyond Wooliscroft Road are slag heaps probably left after the closure of the nearby Lillydale Colliery in the nineteenth century. Above the heaps is the row of houses in Townsend Place. The houses shown on the right were part of 'Bottom Row,' which ran parallel to 'Top Row,' both of which have since been demolished.

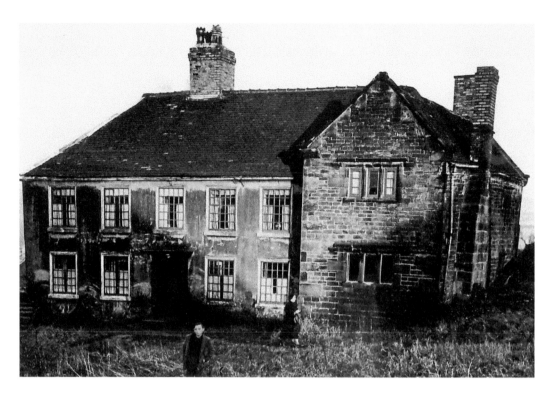

Ubberley Hall, mid-1950s

This photo of Ubberley Hall was taken while it was being used as a temporary place of worship by St Stephen's Church, after the last family to farm it had moved out. This ancient gentleman's residence was apparently owned by Revd W. Clarke in the 1840s and later became known as Ubberley Hall Farm. The Forresters farmed it from around 1871 until the 1950s. Sadly the hall was demolished in 1958 as part of Stoke-on-Trent Council's Bentilee Estate housing development.

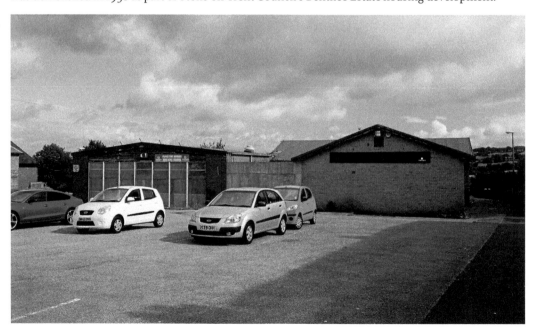

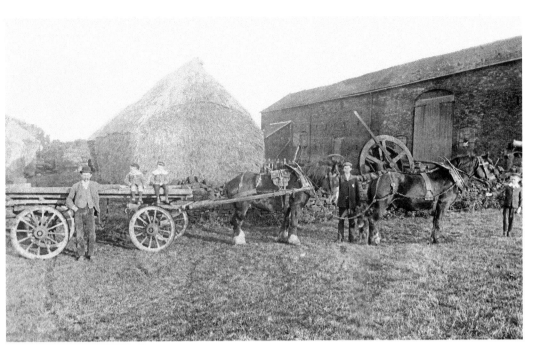

Ubberley Hall Farm

This evocative farm photo shows the large barn that used to stand to the left of Ubberley Hall, as it is shown on the previous page. The photo shows members of the Forrester family proudly displaying their coach-painted 'float' and team of horses in front of the year's stored hay harvest. Using computer techniques, the words 'Ubberley Hall Farm, Bucknall' can be read on the side of the cart but the first words are illegible because of damage to the photo.

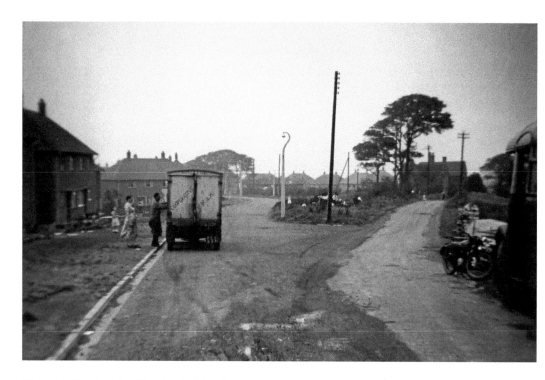

Ubberley Road with Ubberley Hall in distance, _c._ 1957
When the huge Bentilee housing estate was built in the 1950s Ubberley Hall and one other old building were left standing in the Ubberley area. Here, looking along Ubberley Road the hall is visible in the distance. This photo was part of a bus company's bidding process to run the bus services between Hanley and Bentilee. Photographs were taken all the way along the proposed route, each of which was marked with the distance from Hanley Bus Station.

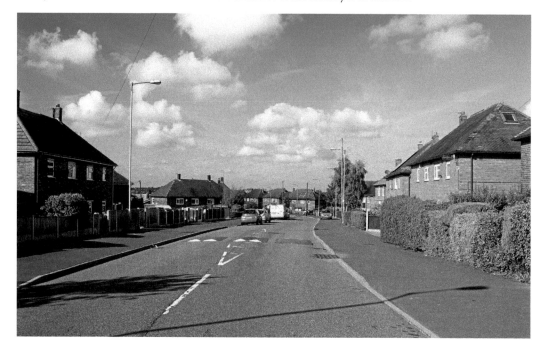

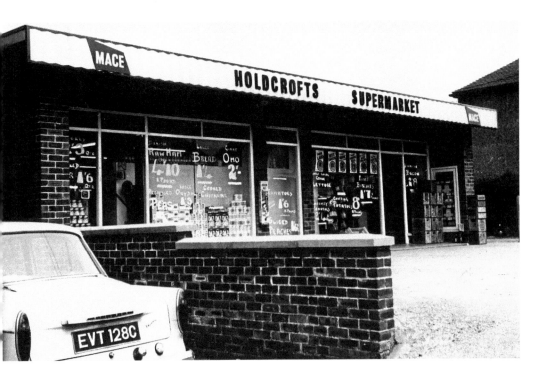

Dividy Road, Holdcroft's Supermarket, late 1960s

Holdcroft's Supermarket pictured here, probably in the late 1960s, was located on Dividy Road, formerly Longton Road. On the Ordnance Survey map of 1898 there was only one building on that side of the road all the way from its junction with Werrington Road to Fenton Road. Mrs Holdcroft originally used to make and sell oatcakes in the shop. The premises are now occupied by Bargain Booze.

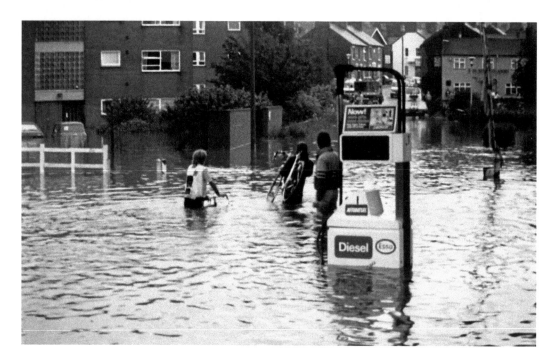

Dividy Road Flooding, 1986

The next older two photos were taken in 1986 when the River Trent flooded, where it flows beneath the road nearby. A skip from Bucknall Park was apparently picked up by the water and washed against the bridge completely blocking the river's escape and causing the water to rise rapidly. This photo shows the view from the petrol station forecourt looking up Ruxley Road. On the right is the Masons Arms, now a private house, and on the left Ruxley Court.

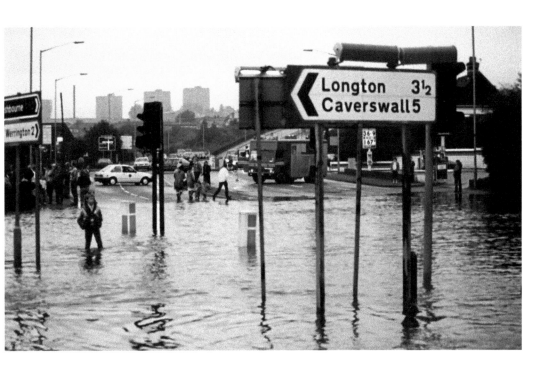

Filling Station Flooding, 1986

This second photo from 1986 shows the view from the flooded filling station looking towards Lime Kiln Bank and Hanley. The River Trent passes under the road roughly at the edge of the flood water. This area is permanently classified as being at 'high risk of flooding ' by the Environment Agency, meaning that there is a 1 in 30 chance of the area being flooded every year; this is particularly likely when there is exceptional rainfall or a large-scale snow melt.

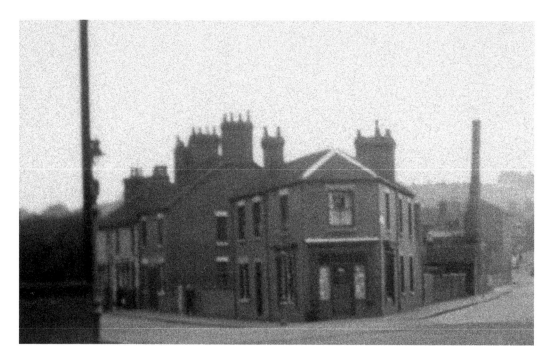

Junction Werrington Road/Dividy Road/Ruxley Road, c. 1957

This blurred but nevertheless very interesting 1950s photo shows the junction of the three major roads in the area: Werrington Road, Ruxley Road (formerly High Street) and Dividy Road (formerly Longton Road) now occupied by the petrol station. Before it was demolished the shop on the corner was an 'old-fashioned' haberdashery and material shop run by a woman. To the right of this shop is the flint mill shown on page 15. Everything shown in this photo has since disappeared.

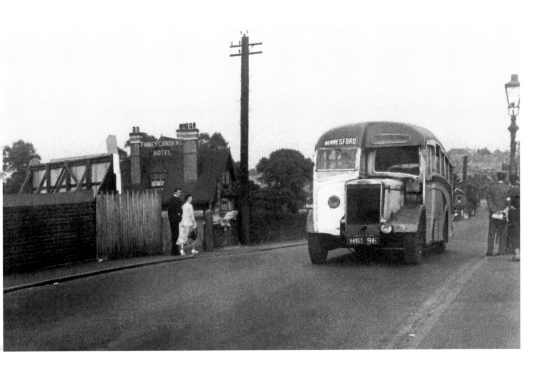

Bucknall Road/Finney Gardens Pub, c. 1957

This old photo shows a Berresford's single-decker bus heading for Hanley across the railway bridge near Bucknall Station. On the left is the Finney Gardens Hotel and to the right, Ruxley Road and its flint mill. The new photograph shows a 1968 Leyland open-topped double-decker named 'The Red Pearl' and driven by 'Captain Jack'. This bus, owned by Stantons Coaches of Stoke was travelling around the City promoting the Douglas MacMillan Hospice's 'Pass The Pound Day' fund-raising activities.

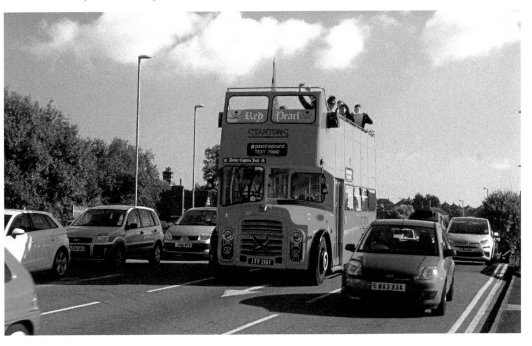

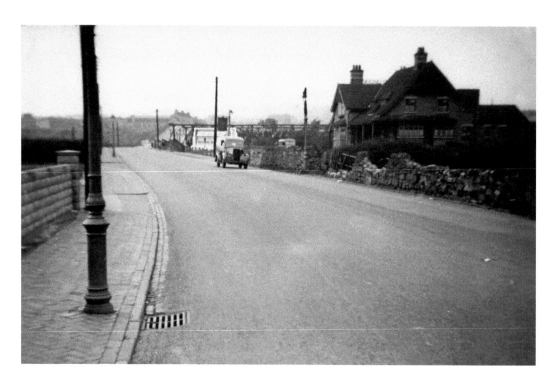

Bucknall Road/Finney Gardens Pub, 1957

This photo looking towards Lime Kiln Bank shows the Finney Gardens Hotel at the side of a Bucknall Road virtually devoid of traffic. Today there are often five lanes of traffic bumper-to-bumper along this stretch of road. The modern photo also gives the impression that the road is quiet but was taken just after queues waiting for Lime Kiln traffic lights had moved away. The station and the sawmill have now gone, replaced by housing and a car wash.

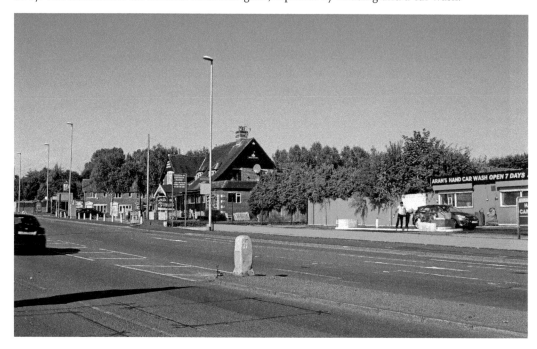

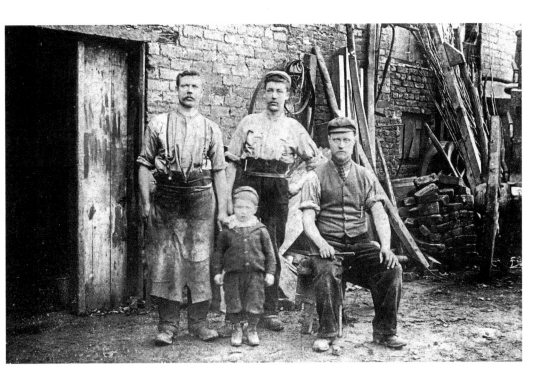

Bucknall Smithy, c. 1900

Bucknall Smithy was located on Abbey Road, just on the Stoke side of Lime Kiln Bank. At this time the smithy was run by the Perkin family who moved from there to Tomkin, near Bagnall, and from there to Endon. When at Endon in 1937, 'Charlie' Perkin became the Champion Blacksmith of All England. The last of this dynasty, (Charles) Geoff Perkin, only retired from smithing at the new forge in Endon in 1990. Today Holdcroft's Renault occupies the site.

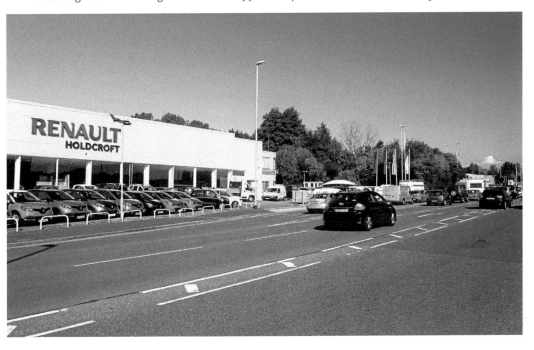

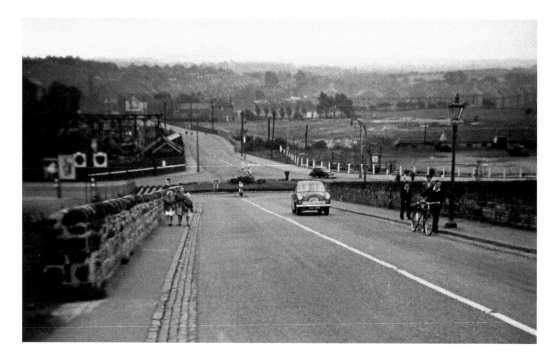

Lime Kiln Bank (Bucknall Road), 1957

This pair of photos shows the enormous changes that have occurred in this area. Taken from Bucknall Road towards Bucknall there is a roundabout at the bottom of the bank in the old photo but traffic lights controlling ten lanes of traffic in the new one. On the right can be seen Bucknall & Northwood Station in its cutting and beyond that a large open area where pottery waste was tipped. Across Bucknall Road from the station was Bucknall Sawmill.

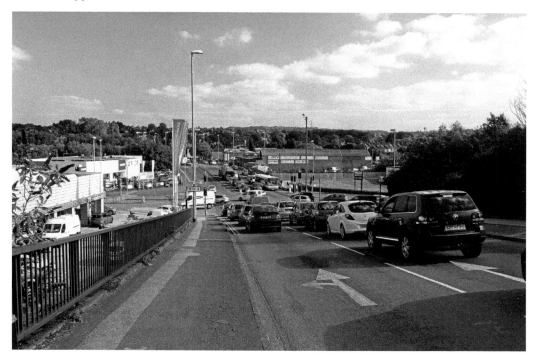

Bucknall Park Cricket Pitch etc

Taken from the City Farm this photo shows the Trent passing through Bucknall Park and a match taking place on the cricket pitch beyond, long since abandoned because of water-logging. Finney Gardens as it was originally called, was the headquarters of the Stoke-on-Trent Constabulary Sports Club. The skip outside the farm gates may be the one that the floods of 1986 picked up, carrying it to Bucknall Bridge where it lodged, blocking the river and flooding the road (see pages 24 and 25).

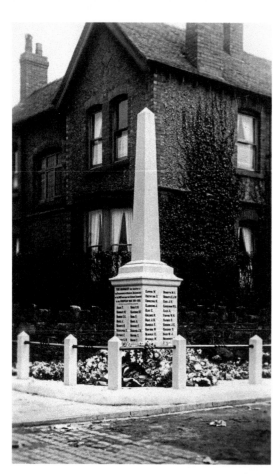

Bucknall War Memorial

Bucknall war memorial stands at the junction of Werrington Road and Marychurch Road. An inscription states: 'This monument was erected by the Parishioners in grateful remembrance of the men who made the Supreme Sacrifice in the European War 1914–1918.' It bears the names of eighty war dead from the area, all from First World War but unusually had no additions made to it following the Second World War. The photo was probably taken soon after the unveiling of the monument.

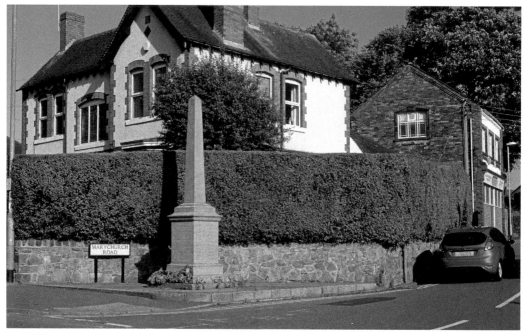

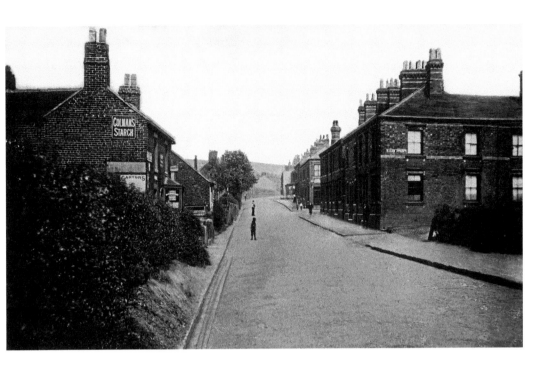

Werrington Road and Baker Street

This view looking up a very quiet Werrington Road was taken from outside today's Staffordshire Meat Packers, a very successful slaughtering and meat processing/retailing company. The shop on the left is now their premises. On the right is Baker Street, renamed Pennell Street in 1954, and beyond it New Street (now Guy Street). On the right in the distance is the Travellers Rest, with what look like bay windows; the present Travellers appears to date from the 1930s.

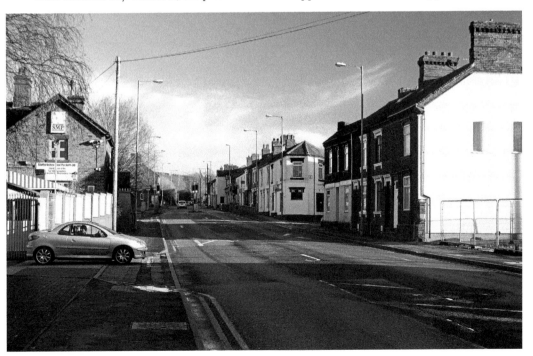

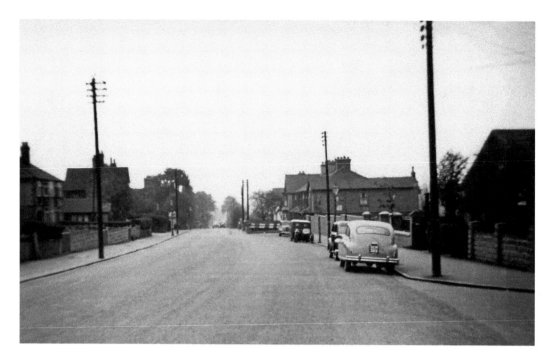

Werrington Road, looking south, c. 1957

The centre of Werrington Road is probably not an ideal place to take a photograph from today but this scene has probably changed relatively little in the period between the photos. The trees, only saplings in the 1950s, are now much larger, as is Bucknall Community & Bowling Club with its bowling green tucked behind the wall at the edge of the pavement. In 1900 there were no buildings between today's Staffordshire Meat Packers and North Street (since demolished), only a few fields.

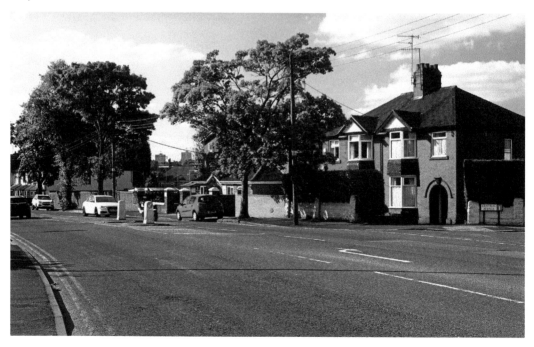

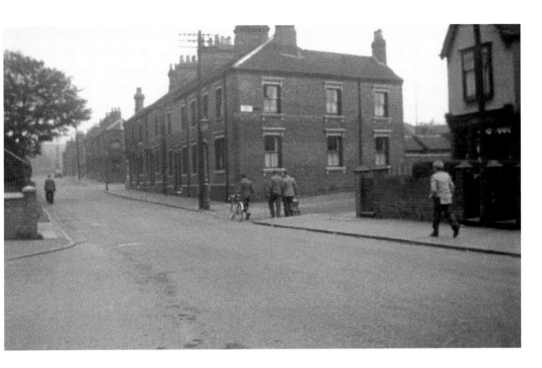

Werrington Road and Pennel Street, *c. 1957*

This old photo was taken from outside today's Co-op supermarket and shows the end of Pennel Street, some properties clearly having been demolished on the corner. The presence of a large mast attached to an out-building probably indicates the residence of an amateur ('Ham') radio enthusiast. Ham-radio was a popular pastime in this period. As with many of these 1950s photos the visible 'traffic' in this area consists of just one vehicle, in this case parked outside a house.

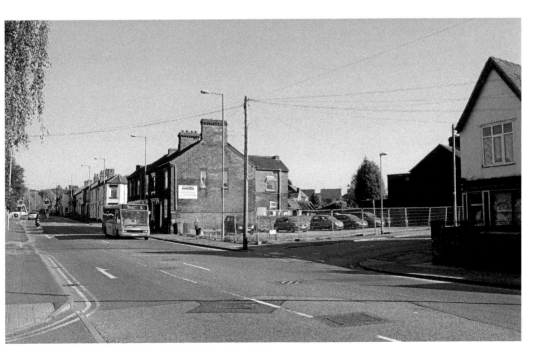

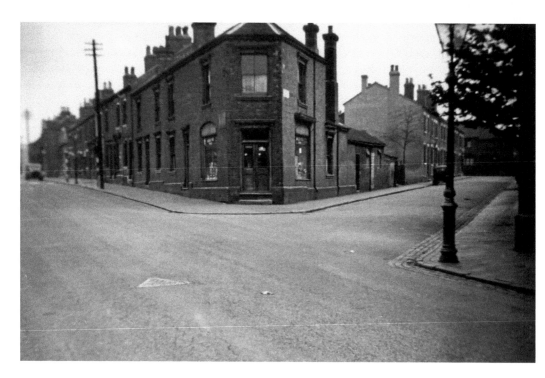

Werrington Road and Guy Street, c. 1957

This 1950s photo was probably taken immediately after the one on the previous page as the same solitary car is parked at the side of the road in both. In this image the full length of Guy Street can be seen, from the grocer's on the corner (now K&K Hair & Beauty) to the semi-detached houses on the far side of Ruxley Road.

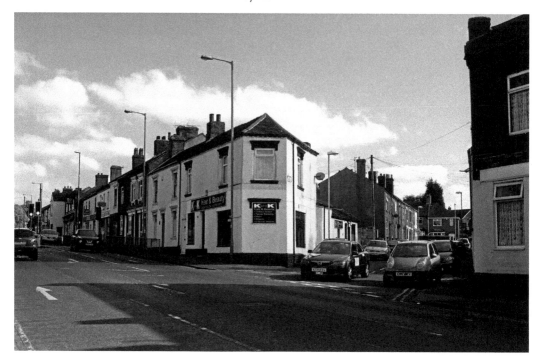

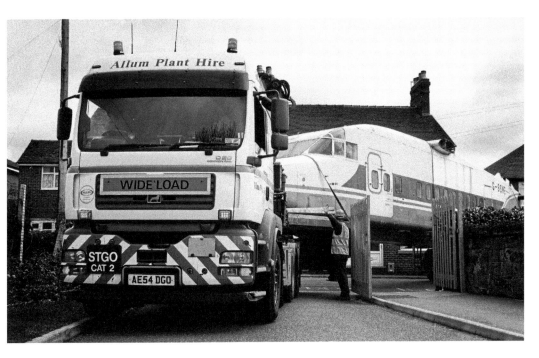

Short S360 aircraft 'Laura' landing at Kingsland Primary School, 2009
This photo shows Kingsland Primary School taking delivery of its new 'classroom', an 82-feet-long Short S360 aircraft. The purchase price of less than £20,000, was half the cost of a similarly-sized mobile classroom. Delivery on 31 March 2009 was not without its problems though as the plane on its low-loader first damaged a satellite dish on a terraced house and then struck a lamp post in the grounds. Originally called 'Laura', a year two pupil suggested its new name 'Phoenix'.

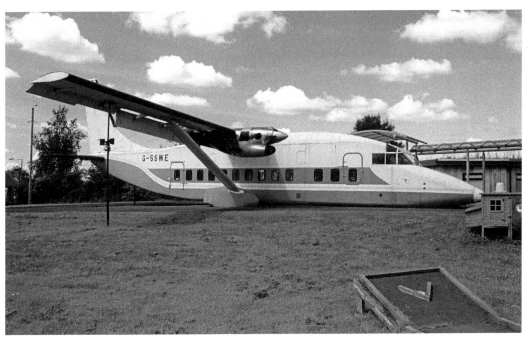

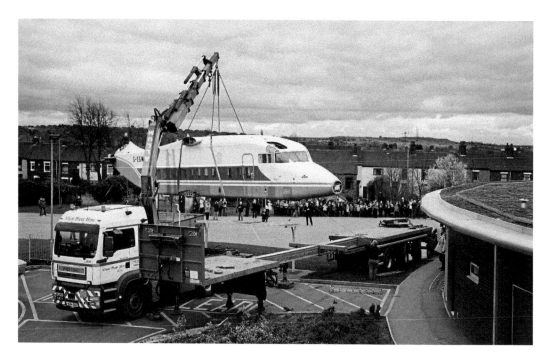

Short S360 aircraft 'Landing' at Kingsland Primary School, 2009
Here 'Laura', is hoisted into place by the crane on the tractor-unit that had transported it to the school. Once the fuselage was in situ the wings, engine casings, tail-fins and nose-cone were added. Supports were installed beneath the wings and the plane was ready to be fitted out to take classes. It had previously been used for flying businessmen to Ireland and Spain. Fully heated, it also has a rainproof walkway allowing pupils to gain entry without being soaked in wet weather.

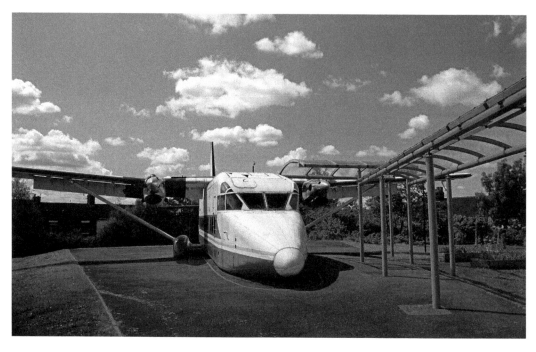

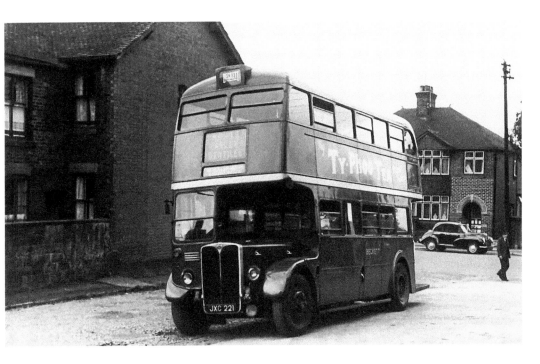

Beckett's AEC Bus at Dean Street, 1959
This is one of Beckett's AEC (Associated Equipment Company) double-decker buses, JXC 221, photographed in Dean Street, Townsend in 1959. Townsend Garage, where Beckett's were based, is just out of shot to the right, on the corner of Dean Street and Eaves Lane. The bus's destination board reads Hanley–Bentilee, the route that many of the 1950s photographs included here were part of the bidding process for. This bus, bought from London by Beckett's was sold to PMT in March 1963.

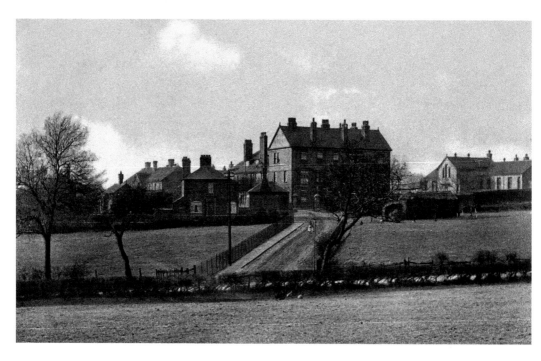

Bucknall Hospital from Field Opposite

Bucknall Hospital was built in 1886 to treat patients with smallpox but following the Second World War it was converted into a specialist centre for the treatment of the elderly. It was finally closed in 2012 after NHS managers said that it cost more than £1.5 million per year to keep it open. Planning permission has been granted for the building of nearly 200 houses on the site and work was expected to start in 2015 but has still not begun.

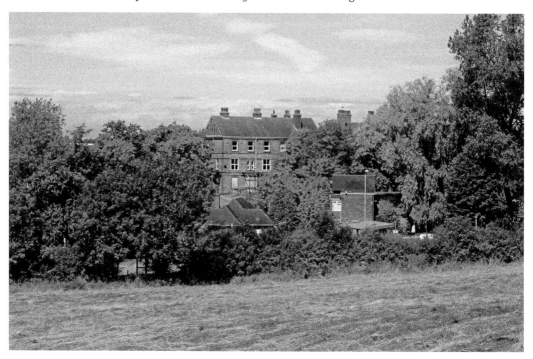

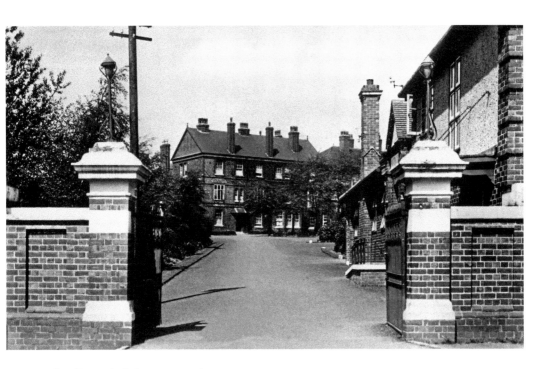

Bucknall Hospital Gates, c. 1946
By the time Bucknall Hospital closed in 2012 the former grandeur of its front gates had been largely lost; the lodge-like building on the right that contained the 'Waiting Hall' had been greatly reduced in size and the gates moved higher up the drive. Today the trees have grown much larger making the buildings more difficult to see from the gates and the only occupants today are 24-hour security guards preventing the buildings being looted for their piping/wiring etc.

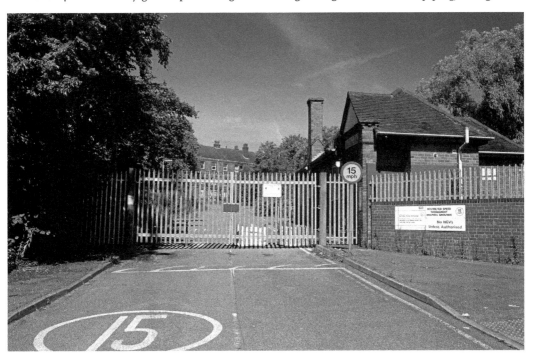

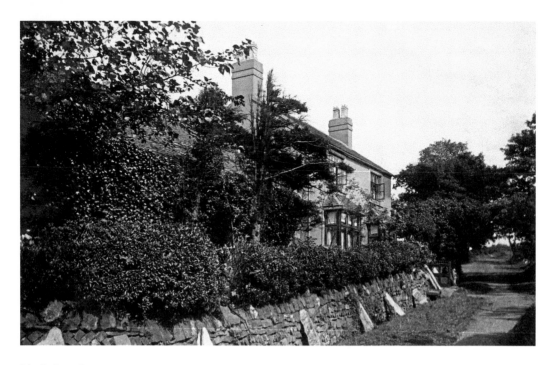

Birch Gate Farm

Birch Gate Farm stood in a rural lane, now called Birchgate and lined on both sides by housing. Between 1891 and 1936 Birch Gate Farm was occupied by John Clewlow Fenton, a butcher working from home and living on his own account. He presumably reared and butchered animals on the farm and either sold the meat himself or supplied it to other local butchers. He certainly did well enough out of his meat to employ a general servant and leave £3,500 when he died.

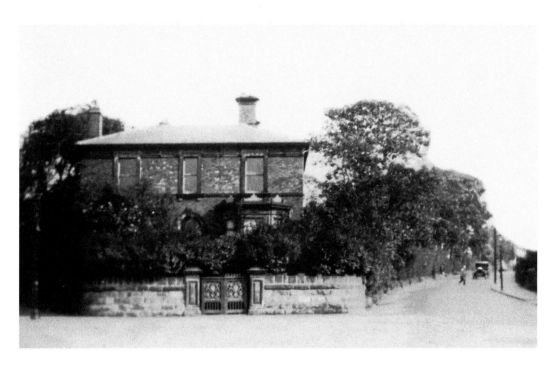

West View, 1930s

West View faced Werrington Road (right) over its junction with Eaves Lane. It was demolished in the 1930s and the *Weekly Sentinel*, which published this photo in May 1956, described it as the 'old residence of the Jackson family'. Between *c.* 1896 and *c.* 1903 it was the home of Darius Roberts, an earthenware manufacturer from Hanley, and in 1911 J. H. Ball, a London-born auctioneer and furniture seller lived there, so perhaps the Jacksons had lived there when it was first built.

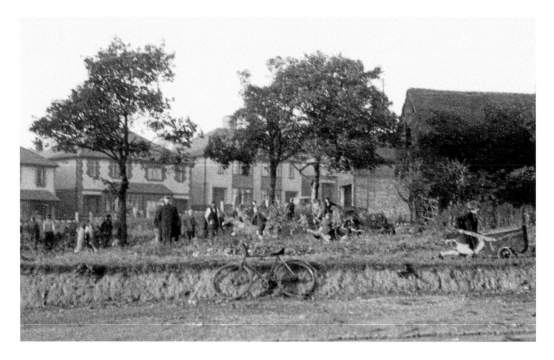

Clearing the site of West View, *c.* 1938

This rather poor photo shows West View's garden (see previous page) being stripped of its timber by locals. They were presumably told that before the new hotel was built they could take to burn whatever they could move. On the right a young girl rushes home with an old pram presumably loaded with small pieces of timber. The 'new' houses in today's 'Birchgate' had already been built and the old buildings to the right may been outbuildings to West View or Birch Gate Farm.

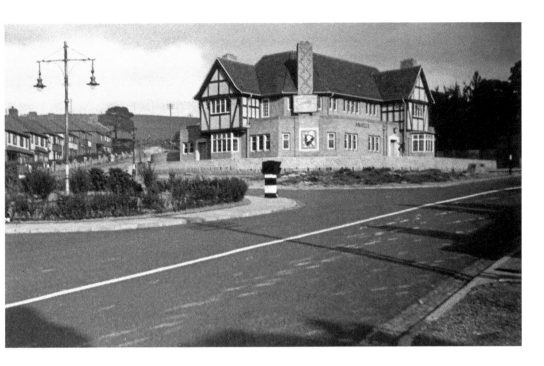

Werrington Hotel at time of Opening, 1939

The mock-Tudor Werrington Hotel is believed to have opened on 3 September 1939, the same day that war was declared on Germany. It remained open until the late 1990s by which time its name had changed twice, to the rather less classy Pig & Whistle and then The Werrington. Around six months after closure it was damaged by arson and subsequently demolished. The site is now covered by a housing development, but the original cobbled entrance drive to the pub has been retained.

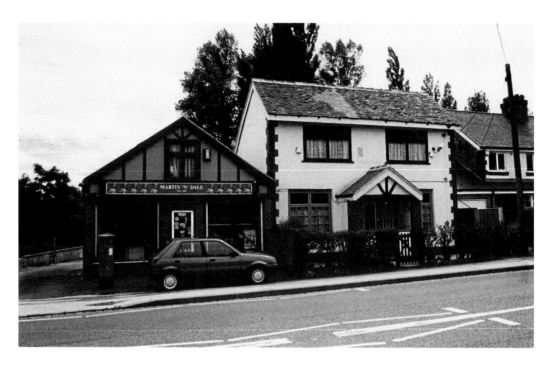

Martin 'n' Dale Grocers and Innovations

Martin 'n' Dale's Grocer's stood close to the boundary between Stoke-on-Trent and Staffordshire Moorlands and where Werrington Road becomes Ash Bank Road. When it closed in the late 1980s both the shop and the detached house next door were bought by Gary Cosgrove. The old shop, shown here after closure, was demolished *c.* 1990 and the site used for an extension to the house, now the showrooms of Innovations, who create high-quality bespoke kitchens, bathrooms and loft conversions.

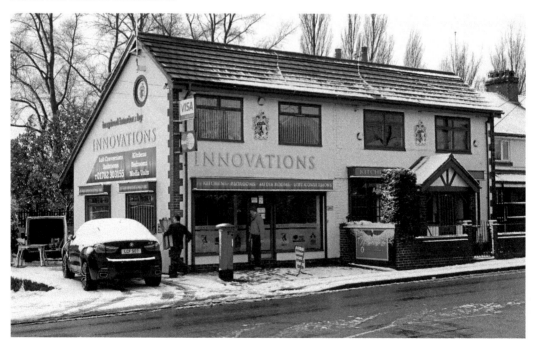

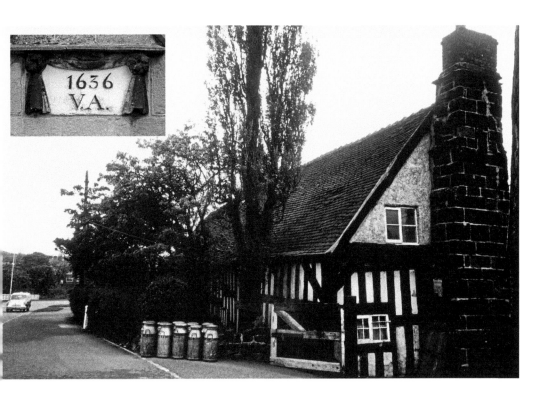

The Brookhouse, Front, 1960s

The Brookhouse stood on Werrington Road 'next door' to the properties on the previous page. It was a timber-framed house of 1636 with central porches front and rear. In *Werrington: Some Notes on its History*, J. D. Johnstone said that there must have been an earlier house there because the foundations and chimneys were made of stone. This was actually normal practice for timber-framed houses though because the stone kept the beams clear of wet ground, preventing rotting – and wooden chimneys somehow never caught on.

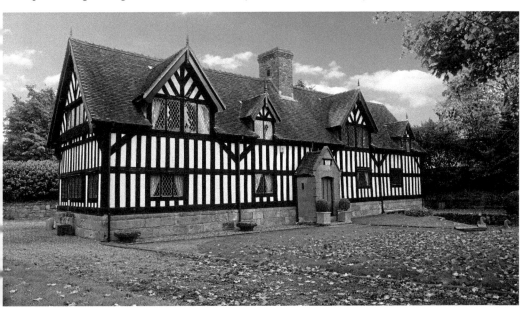

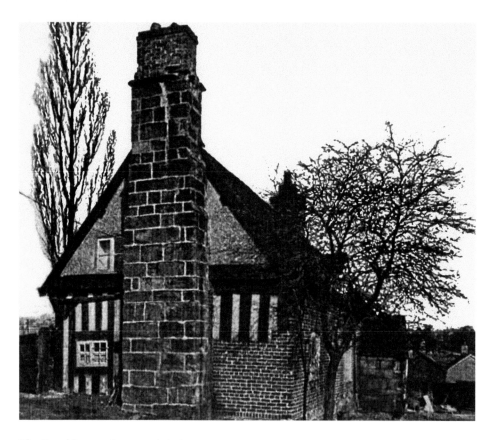

The Brookhouse, Rear, undated

The Brookhouse was completely dismantled in 1972 and rebuilt in the country village of Knighton, Shropshire, around twenty miles away. The house was beautifully restored and although threatened with demolition when in Bucknall, when offered for sale in its new location in 2012 it had a guide price in excess of £1 million. This view of the rear shows that over time some of the beams must have suffered from rotting and the house had been 'patched' with brick.

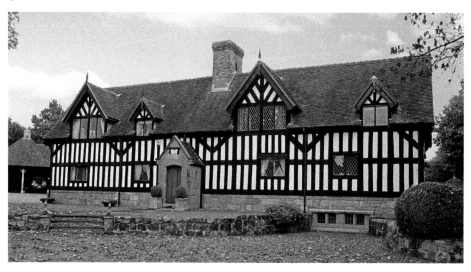

**Mason's Marks
on The Brookhouse, 1972**
This fascinating photo
shows stones supporting
the timber-frame of The
Brookhouse. The marks on
the stones are not ancient
graffiti but mason's marks,
cut to show which mason
had cut and 'dressed' each
stone so that he would be
paid appropriately for his
work. The timbers above
would probably have been
marked in a similar way
but in that case to show
which one connected
to which after the house
had been ox-carted from
the joiner's yard to the site.

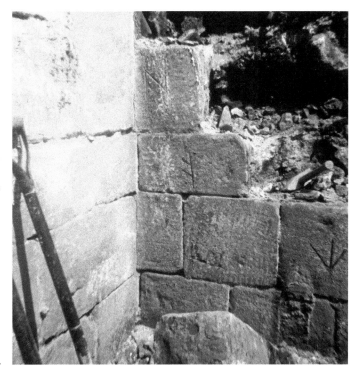

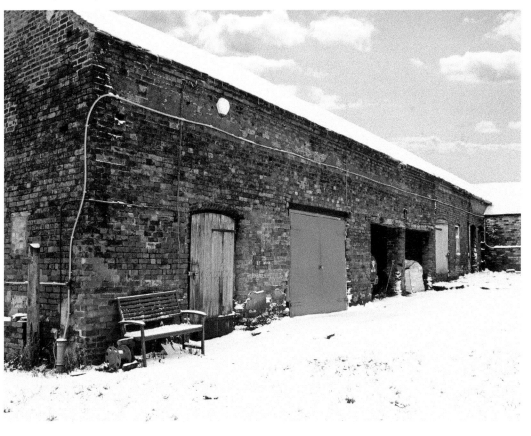

49

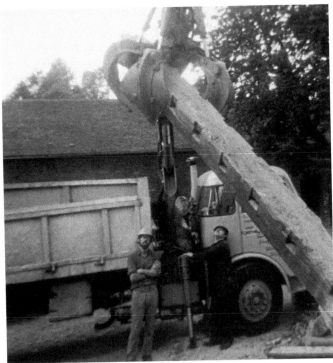

Loading up roof timber of The Brookhouse, *c.* 1970s
This early 1970s photo shows one of the roof timbers from The Brookhouse being loaded up on to Zbigniew Jedlinski's lorry ready to be transported to the site in Knighton where the house was going to be rebuilt. What a pity that no close-ups were taken of the beams to show the joiner's marks that were probably present at each end. The young man is Ian Bailey whose father had conceived the idea of buying and translocating the house to Shropshire.

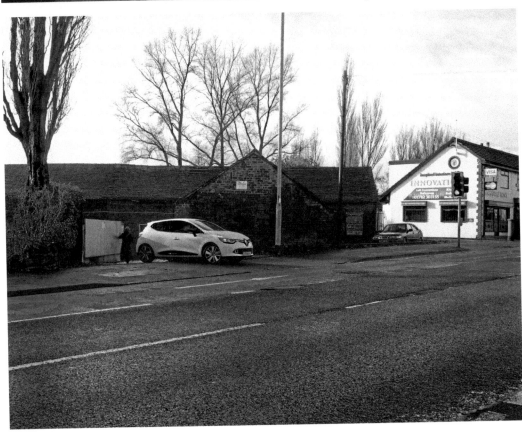

Little Brookhouse

Little Brookhouse Farm is located down a steeply sloping drive from Ash Bank Road just a few metres inside the Stoke-on-Trent boundary. It is situated close to the Causeley Brook which has flowed down from Wetley Moor. Severn Trent say that there is a slight risk of flooding here but not as great as near the Trent Bridge. Little Brookhouse, a farm of 27 acres, was farmed by William Dale for at least forty-five years between 1851 and 1896 when he died.

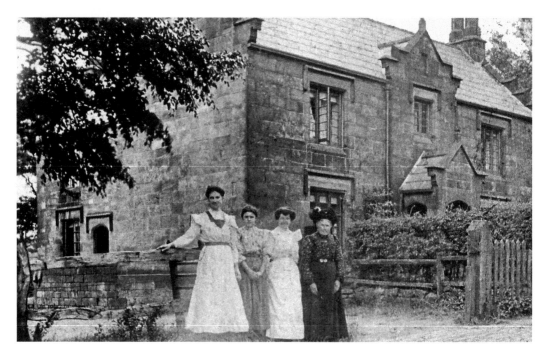

Mettle House Farm

This ornate mid-nineteenth century farmhouse stands on Ash Bank Road, below the entrance to Ash Hall. As early as 1861 though, it was not occupied by a farmer but was the home of Commission Agent David King from Lancashire. Commission Agents acted as intermediaries in business deals, for which they received a commission. Perhaps King sold Job Meigh's pottery to other countries in return for a share of the profits. Today Mettle House is home to the Wise Owl Nursery.

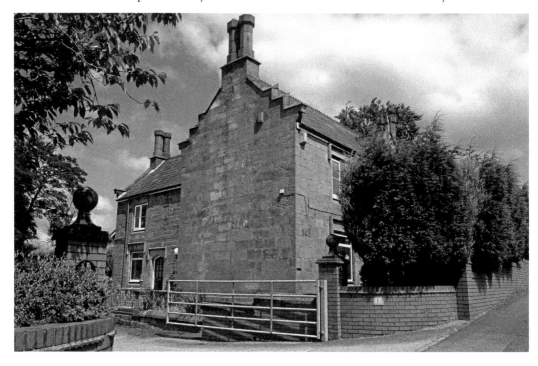

Ash Bank/Ash Bank Hotel, 1961

This 1960s view of Ash Bank Road is more significant for what it doesn't show than for what it does. On the left is just one corner of what was Ash Bank House, now The Ashbank. On the right must be the drive to Ash Hall with its ornate lodge. Given how narrow Ash Bank Road was at the time, the lodge must originally have stood well back from the road and so does not appear in the photograph.

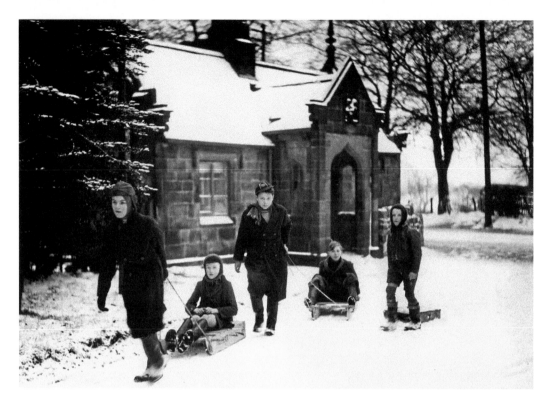

Ash Hall Lodge

Ash Hall Lodge was built at the same time as the house it served and was occupied by 1841. It was generally used to house Job Meigh's coachman/groom. Originally it consisted of only two rooms and a storeroom but was extended before 1857 and once or twice since, most recently in the 1980s. In 1861 the lodge housed German Dean, a coachman, and his wife, their five-year-old daughter and the wife's widower father aged seventy-three; quite a squeeze one imagines.

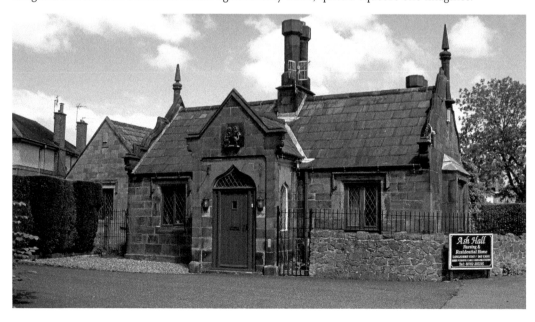

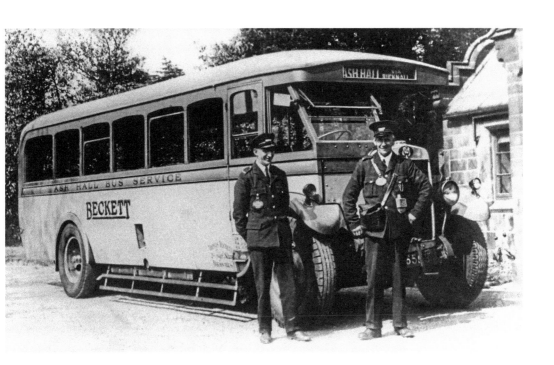

Beckett's Bus at Ash Hall Lodge

Rather appropriately this Beckett's single-decker bus was photographed outside Ash Hall Lodge. The Beckett service travelled from Hanley to Ash Hall between 1930 and 1963 and having reached Ash Hall would turn around and head back down Ash Bank. Why did the service only go half-way up the hill you might wonder? And what hard work it must have been for the mainly elderly vehicles in the Beckett's fleet? Eventually Thomas Beckett sold out to PMT, as did most of the independent bus companies.

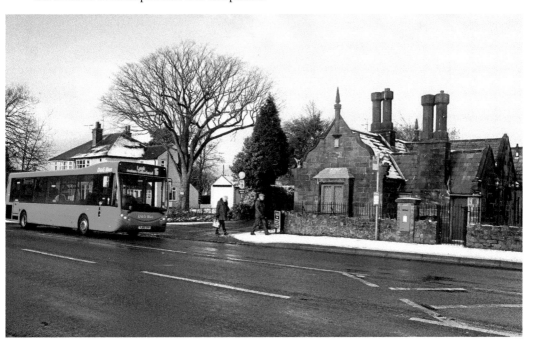

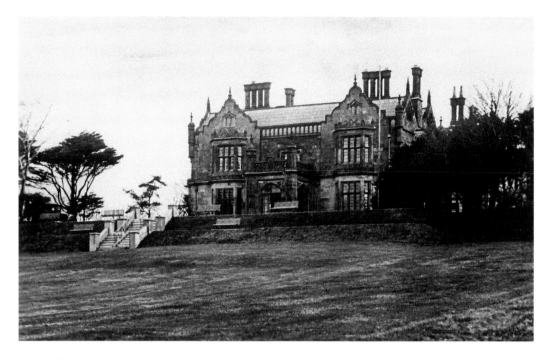

Ash Hall Golf Links Hotel

Ash Hall was built for pottery owner Job Meigh II in 1837 and Meigh lived there until his death in 1862. After Mrs Meigh died, her son William Mellor Meigh moved from Ash House, across the road, into Ash Hall and remained there until 1922. Builder James Grant then bought the house and turned it into a hotel with a nine-hole golf course, as shown. Grant also built the houses along Ash Bank Road. The house has since been offices and a nursing home.

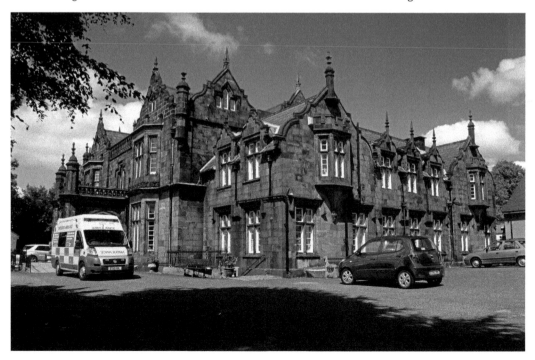

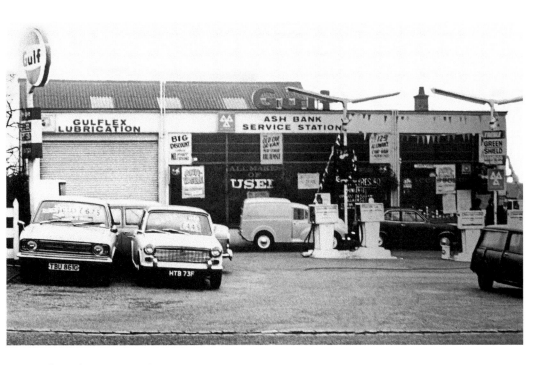

Ash Bank Garage, 1960s

Ash Bank Garage was bought by Thomas Beckett, founder of Beckett's Buses, soon after the Second World War, primarily to give his buses a place to turn around and head back to Hanley after stopping at Ash Hall. It was also used as parking place for newly acquired buses and a place to keep Beckett's tow-truck. The garage was sold to Gulf Petroleum *c.* 1963 when the Ash Hall bus service stopped. It was taken over by Mike West in 1969.

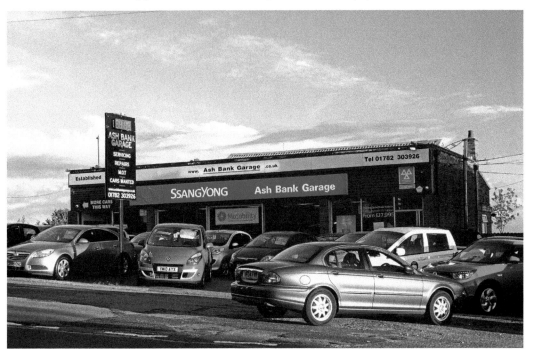

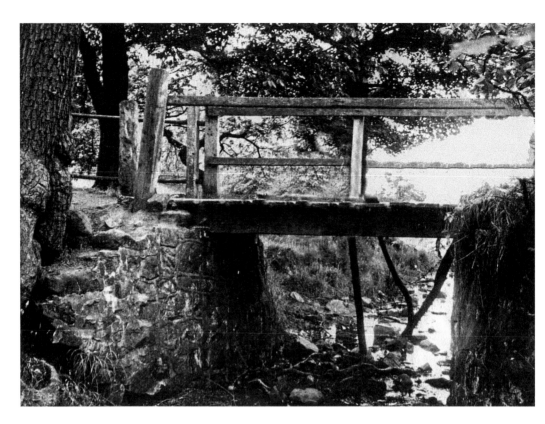

Footbridge over Causely Brook, 1960s

This bridge crosses the Causely Brook close to Ash Hall. The bridge is on the bridle path running from the road aptly named Bridle Path, a little way above Ash Hall Lodge. A little further along the path from the bridge is a 'crossroads' with the right-hand fork going to Wetley Moor, the left-hand one to Brookhouse Lane and straight on, leading to a network of other paths heading in every direction. These paths are popular with local youngsters.

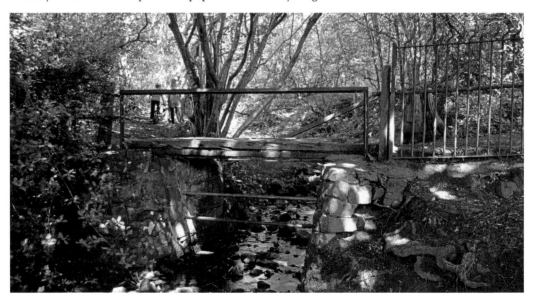

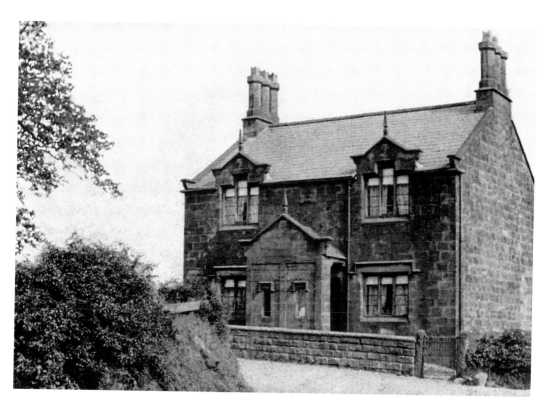

Old Cottages by Werrington Crossroads

This pair of houses has changed relatively little externally since they were 'Erected AD 1854' as stated on the plaque in the centre of the front wall. What has changed dramatically though are the roads that surround them; Salters Lane remains narrow and becomes narrower the further along it you go but Washerwall Lane and Ash Bank Road are now constantly busy with streams of traffic, so much so that traffic lights had to be installed there many years ago.

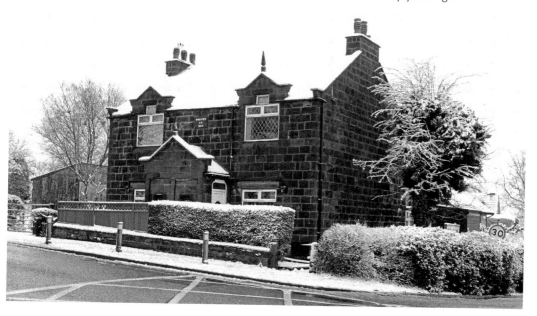

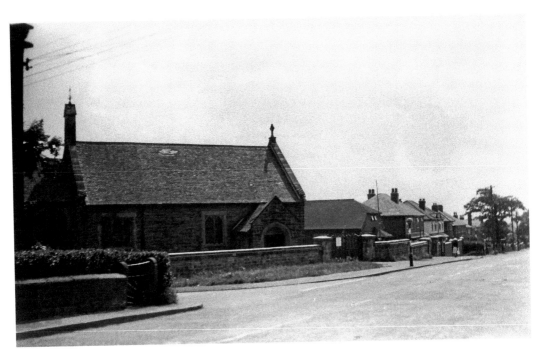

Werrington Crossroads and St Philip's Church, *c. 1960*

This 1960s photo shows some of the cottages shown in the previous photo and St Philip's church. In the early 1800s Werrington had a 'chapel of ease', where services were held so that Werrington worshippers did not have to travel to Caverswall. This 'chapel' (actually a barn) became part of the Industrial School in 1868 but was already out of use by then. From 1878 services were held in the 'Council School' and then in 1906–07 St Philip's finally became Werrington's proper Anglican Church.

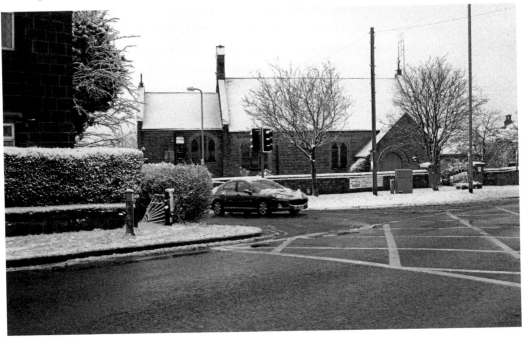

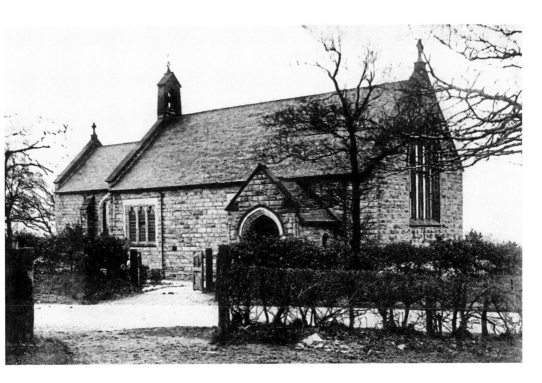

St Philip's Church

The land on which St Philip's was built was donated by William Meigh of Ash Hall. The foundation stone was laid in 1906 by the Countess of Harrowby, from Sandon Hall, and the church, built in the Perpendicular style, was dedicated in June 1907. St Philip's is built of local stone, with the exception of the windows, which are of Hollington stone. The interior was modernised and the front porch altered in time for the church's centenary in 2007.

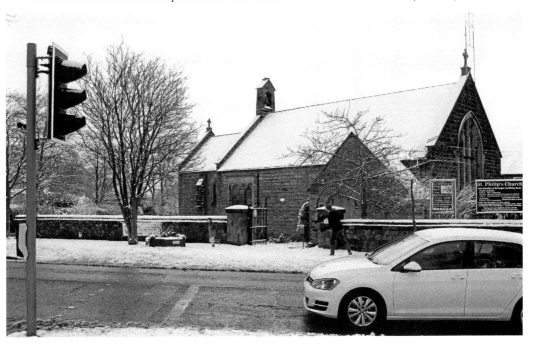

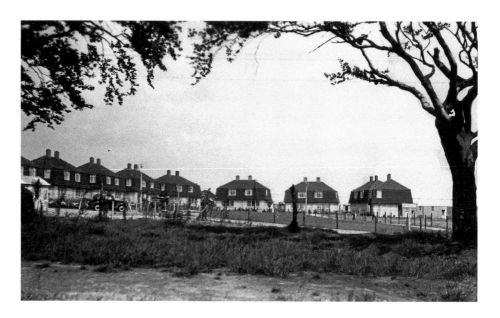

Salters Close, off Salters Lane

Salters Close is a small cul-de-sac of originally Prison Officer's houses built just off Salters Lane in the late 1950s. They are unusual houses with tiled Mansard roofs like those in Greenfield Avenue, Brown Edge and former council estates throughout the area. Today Salters Close is also the site of Werrington NHS Clinic which serves as a base for District Nurses, Health Visitors, Children's Services and Children's Community Nurses. The clinic, formerly the prison social club, opened in the 1970s.

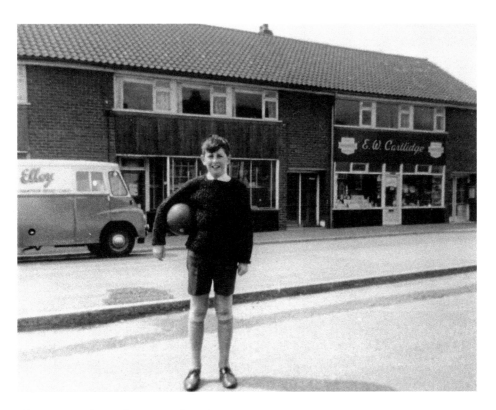

Shops in Washerwall Lane, early 1960s

Photographs such as this 1960s image of an unknown boy with his football, often have informative backgrounds and this view of Washerwall Lane shops is no exception. On the right is E. W. Cartlidge's hardware shop, now Just Jeff's Hair Salon, and next door with no apparent name sign is what is now 'Just For Kids' (JFK). The remaining two shops are now occupied by the Co-op. The shops were built *c.* 1960 approximately in the corner of the small field on page 65.

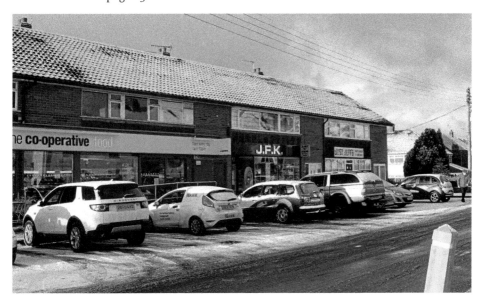

Washerwall Lane, from upstairs at No. 51, 1950s

Werrington has expanded enormously since the 1930s and nowhere is this more obvious than in the Washerwall Lane/Washerwall area. In this 1950s photo taken from the front bedroom window of No. 51 Washerwall Lane in the direction of Abbey Hulton, nothing is visible except farmland with just one or two isolated farm buildings visible in the distance. The tree on the right still survives and now stands on the junction of Washerwall Lane and Uplands Avenue.

Washerwall Lane, from upstairs at No. 51, 1950s

This 1950s photo was taken from the same window as the previous one but now looking in the opposite direction along Washerwall Lane. Once again it shows mostly farmland and between the photographer and Ash Bank Road there appear to be only one or two houses, no shops and no primary school. What can be seen, to the right of the nearest telephone pole, are St Philip's Church completed in 1907 and Werrington Village Hall built around thirty years later.

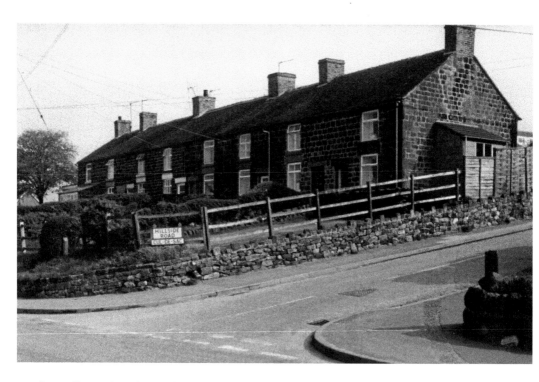

Washerwall Lane junction with Hillside Road

The old photo here shows the row of cottages at the junction of Washerwall Lane and Hillside Road. Although not all that old it shows the differences that can be made to even a row of basic stone-built cottages. The end cottage alone has been re-roofed, had a porch added and five new windows inserted in the end wall. The front windows have also been raised above the roof-line and tiled gables added above them.

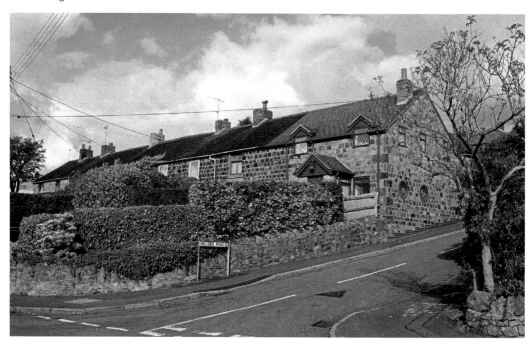

Washerwall Lane, Dale's Shop

This local shop was situated in a cottage in the old hamlet of Washerwall. Even though the shop closed in the 1980s, the sign is still in situ above the door and proclaims 'S. Dale, Licensed to sell tobacco'. The last person to run the shop was Daisy Dale who lived there surrounded by her family; her brother lived in the house next door and her sister Ivy in Bleach Cottage (see next page). When the shop closed Daisy moved in with her sister.

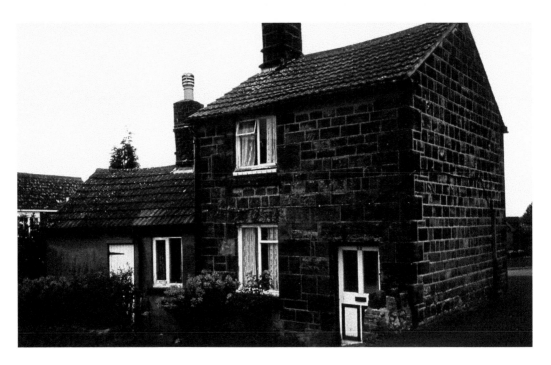

Bleach House, Washerwall

Bleach House stands on the corner of Washerwall Lane and Uplands Croft. It may have acquired its name from the laundry activities that used to go on around the nearby 'Wash-Well', or possibly because the bleaching of newly woven cloth took place there. The well, next to Washwell Cottage, is believed to have given the hamlet of Washerwall its name. Ivy Dale and later her sister Daisy lived in the cottage in the 1980s. The cottage has now been significantly extended.

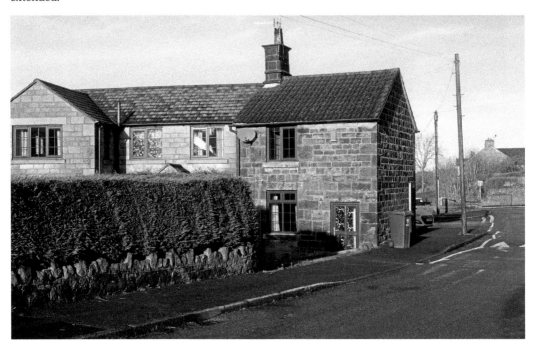

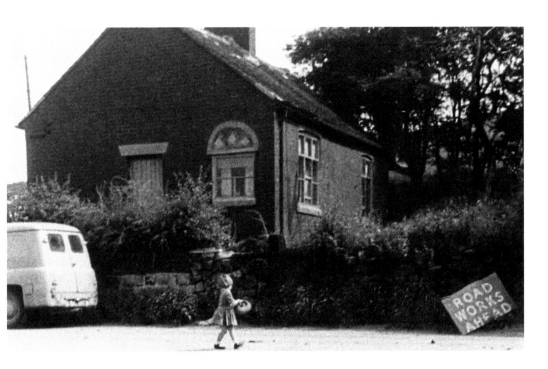

Old Chapel at Washerwall, 1960s

This part of Washerwall Lane was originally the isolated hamlet of Washerwall with its own well, shops, chip shop (briefly), cottages and Methodist chapel. The chapel stood near the junction with the present Moss Park Avenue, between two quarries. It became disused in 1895 and was converted into a bungalow, as shown here. Today both the bungalow, the quarry and the hamlet itself have gone, Washerwall having been absorbed into Werrington. The road here is lined by properties built high above the road.

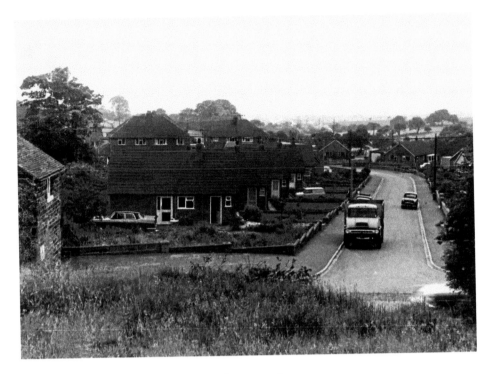

View of Uplands Croft over Washerwall Lane, 1960s

This old photo shows Uplands Croft from the opposite side of Washerwall Lane. On the left is Bleach House (see page 68). The biggest change in Uplands Croft is that the first bungalow on the left has been altered into a house. The new photo was taken from the front patio of a house built high above the road on the site of the old quarry. In the distance in the new photo the edge of a dramatic snowstorm is just arriving in Hanley.

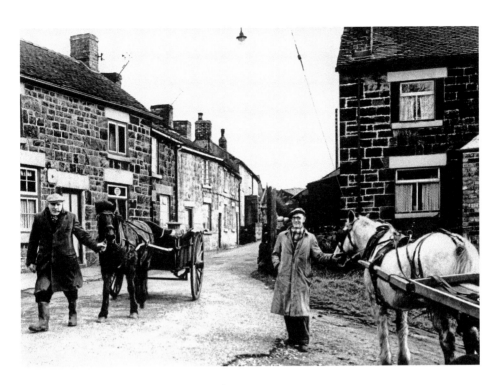

Washerwall Mr Brown with Horse and Cart

Mr Brown on the right was apparently quite a Werrington character travelling around the area with his horse and cart selling sticks to local people for fire-lighting. Behind the other man on the photo is Mrs Mifflin's shop, with an advert for Senior Service in the window. At the far end of the row a chip shop was once opened but for some reason did not survive for long. All of the cottages were eventually demolished but not replaced by new properties.

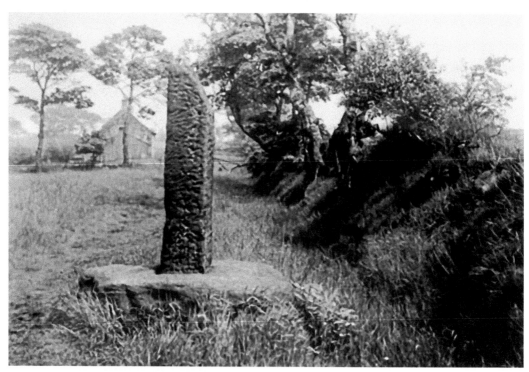

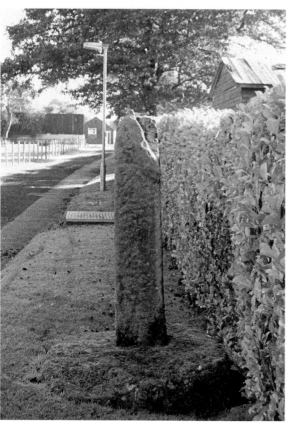

Medieval Cross near Washerwall Lane

This 1.45m broken cross shaft probably originally marked the boundary between Caverswall and Bucknall and is mentioned in relation to 'beating the bounds' in 1803. It has been moved at least once and now stands by the drive to Croft Farm. Until quite recently it was on land at the rear of the large house on the corner of Washerwall Lane and the farm track. It may now have a different base, perhaps because the original was too heavy to move.

Junction of Draw-Well Lane and Ash Bank Road

This pair of photos shows where Draw-Well Lane meets Ash Bank Road. In the old photo Draw-Well Lane passes between the building with the stone end-wall and the nearer block of three houses. In the new photo Draw-Well Lane is also there between Clubsub Dive Centre and its nearer neighbours but alterations to chimneys and windows have made all of these buildings almost unrecognisable. The most noticeable difference of course is the huge telecommunications mast rising from behind the houses.

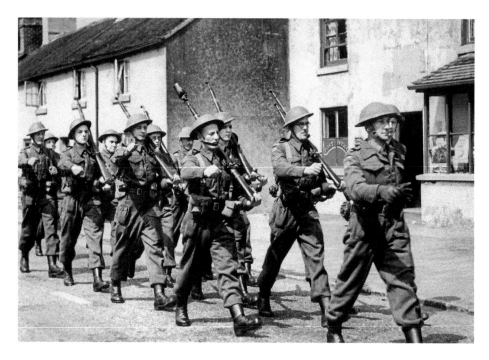

Werrington Home Guard Marching Past Old Werrington Post Office, 1940s
Here Werrington Home Guard march past the Post Office behind Sgt Thomas Capper (see next page) during the Second World War. Originally called the Local Defence Volunteers the name was thought too much of a mouthful and was altered. The nickname 'Look, Duck and Vanish' lasted rather longer. The Home Guard were mostly equipped with First World War American rifles and in this photo one of the leading men is carrying a rifle-mounted grenade launcher, looking a bit like a tin-can attached to the barrel.

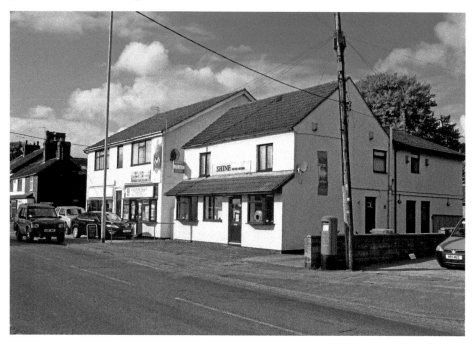

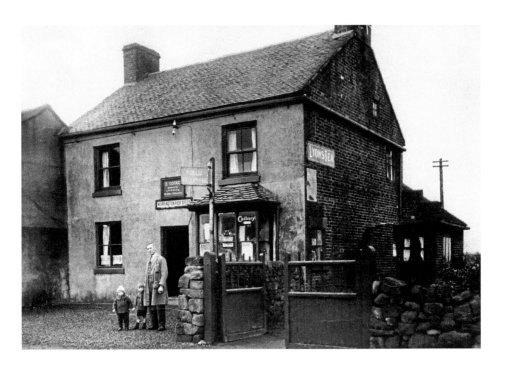

Old Werrington Post Office

Werrington's old post office is believed to have originally been the Blue Ball Public House, closed in 1889. In this photo Postmaster Thomas Capper is standing outside with his children Freda and Billy. Tragically Billy aged just six was killed in a road accident just yards from where he is standing here. He was buried at Wetley Rocks and was joined last year by his sister Freda, who kept the new post office for many years. Freda was ninety-two when she died.

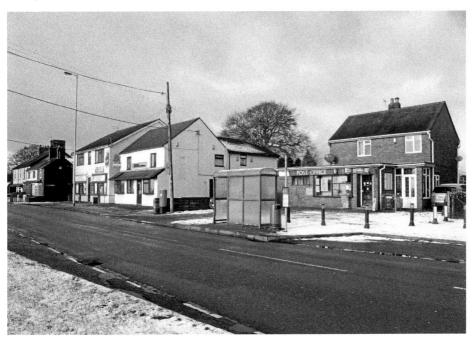

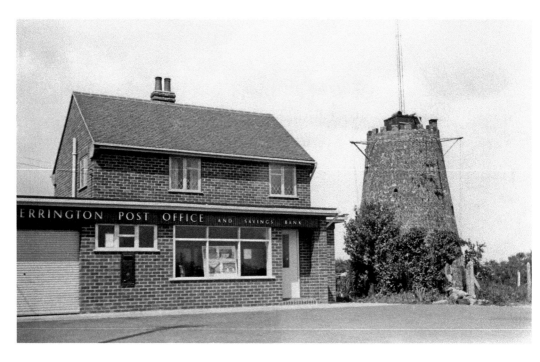

'New' Werrington Post Office and Windmill, *c.* 1960
In this 1960s photograph Werrington's new post office and savings bank has only recently been opened. Next to the brand-new building is the windmill dating back to the 1700s. In 1940 the top was crenellated by the Home Guard who also gutted it and used it as a base. On the top is the predecessor of the huge telecommunications mast, which now stands nearby and dwarfs the mill. When built the windmill would have seemed gargantuan to the local residents.

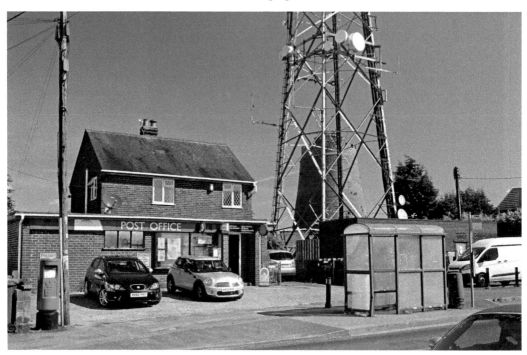

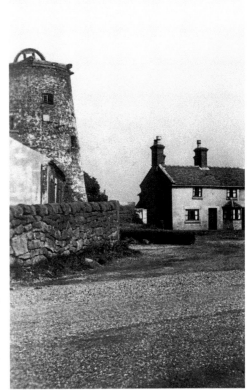

Werrington Windmill and 'old' Windmill Pub, 1921–1930

Next to the windmill was the original Windmill Inn. Although in this photograph it appears not to have a name sign, the licensee's name was Edmund Horleston. In 1911 Horleston, who was born in Washerwall, was the licensee of the Waggon & Horses, Dividy Lane, Longton. In 1921 Frederick Dale was licensee at the Windmill Inn and Horleston was still at the Waggon & Horses so this photo must be post-1921. The 'new' Windmill Inn replaced this one in 1930.

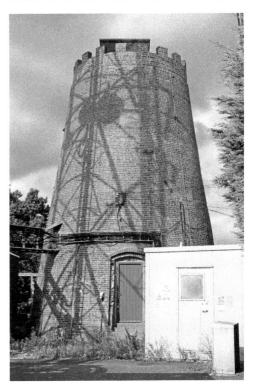

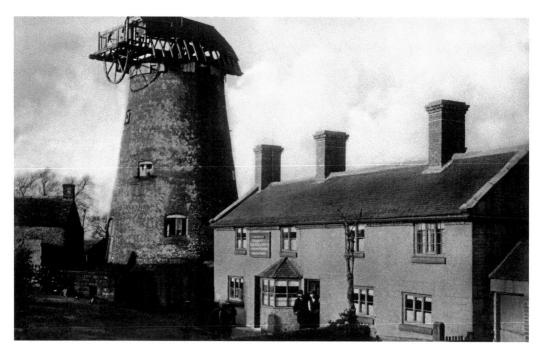

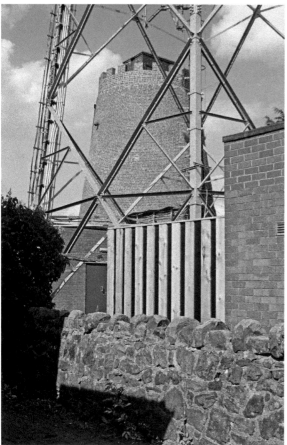

Werrington Windmill and 'old' Windmill Pub

Werrington windmill is believed to date from the 1730s and its last miller was Mark Greatbatch in the 1860s. Greatbatch was a miller and innkeeper and so probably also ran the Windmill Inn; he had previously run the Black Horse in Endon. By 1871 Greatbatch had moved on and was running a pub in Burslem. After being adapted by the Home Guard, the windmill would have formed a good defensive look-out position against lightly armoured road convoys in the case of a German invasion.

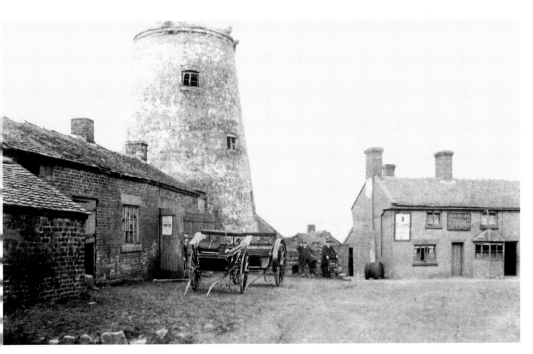

Windmill and old Windmill Inn from the South, 1920s

It is not clear precisely what is being shown in this old photo, which probably dates from the 1920s. The top of the windmill has not been crenellated, making it pre-1940s and the old Windmill Inn may still be serving which would date it to pre-1930. On the door of the windmill outbuilding is a notice bearing the word 'Furniture' in large lettering, possibly suggesting that the contents of a house, or perhaps the pub, is being sold off.

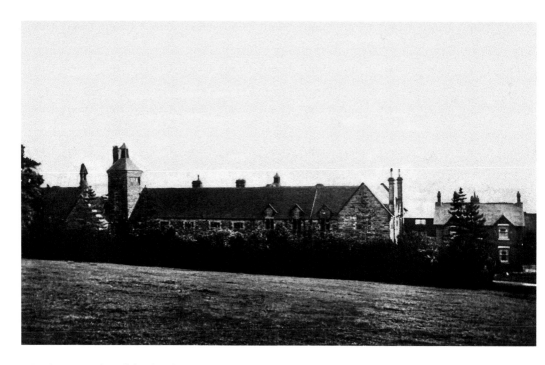

Werrington Industrial School

The County Council Certified Industrial School, sounding rather like a 'Technical College' of more recent times, opened in January 1870. In the 1871 census for the school there were just thirty-one pupils with a large proportion from Stoke-on-Trent and nearby areas. Ten years later they were not pupils but inmates. This was in fact a correctional facility for young boys that in 1933 became an Approved School. In 1881 there were 104 inmates but today its operational capacity is 142 juveniles.

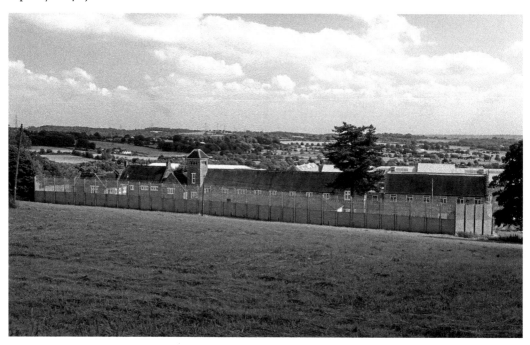

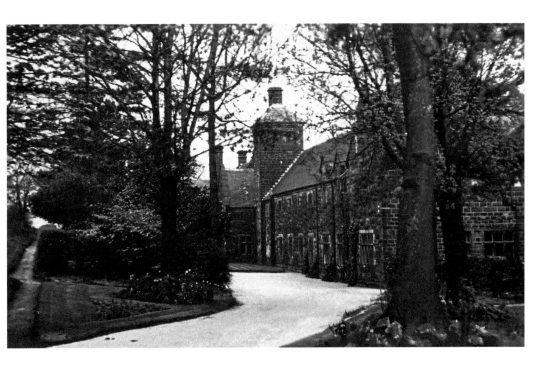

Werrington Industrial School

This second photo of the Industrial School shows some of the original buildings, surrounded by their cultivated gardens. The school was originally based around a farmhouse, two cottages and a barn. When it opened the pupils were largely trusted not to run away but doing so was not particularly difficult. Today, although called Werrington Young Offender Institution, it is classed as a prison and is referred to as such within the justice department. The perimeter is now surrounded by high fences and razor wire.

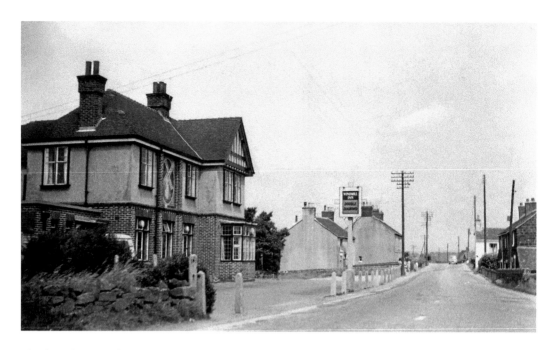

The 'New' Windmill Inn, Werrington

The 'new' Windmill Inn was built in 1930 replacing the previous version shown on pages 77–79. As with most pubs, The Windmill has been extended since it was built and was recently at the centre of a controversial plan to build a mini Co-op supermarket on the car park, despite there being a similar shop half a mile away (see page 63). Falling customer numbers and stricter enforcement of drink-driving laws have resulting in many pub closures, changes in usage and changes to underused car parks.

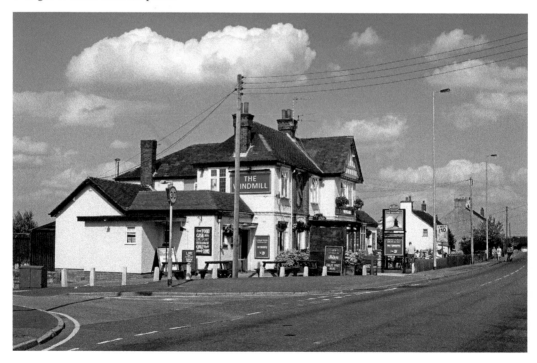

The 'New' Windmill Inn Sign and Cottages Beyond This slightly unusual old photo shows the sign of the 'new' Windmill Inn, complete with its mock windmill vanes, and the cottages that used to surround the pub. The cottage that stood end-on to the road has since been demolished and replaced by a bungalow. A row of properties next to that bungalow now stretches nearly all the way to the Red Cow Inn. The other cottages, although three properties now rather than the original four, still survive.

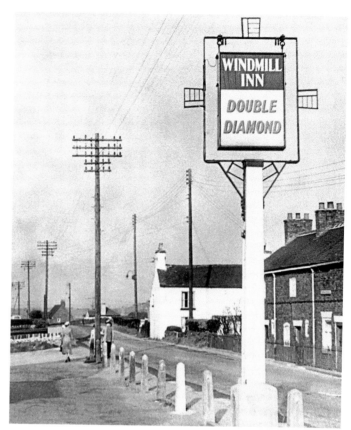

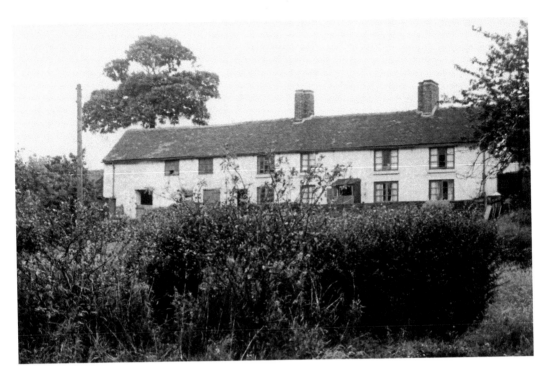

Cottages Opposite the Windmill Inn

This is the rear of the row of cottages that stands opposite the car park to the present Windmill Inn, the fronts of which were shown on the previous photo. From the front the cottages still look like a traditional row but as can be seen from the new photo of the rear, various unsympathetic extensions and alterations have been carried out. The upstairs windows of these cottages offer a birds-eye view of the nearby young offender institution.

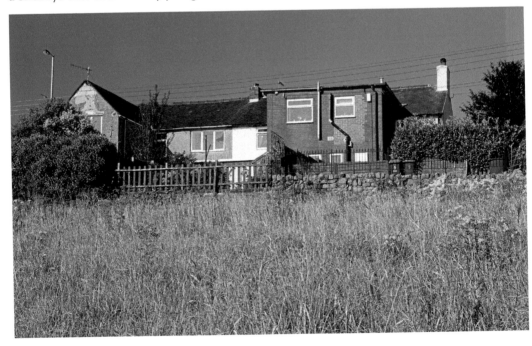

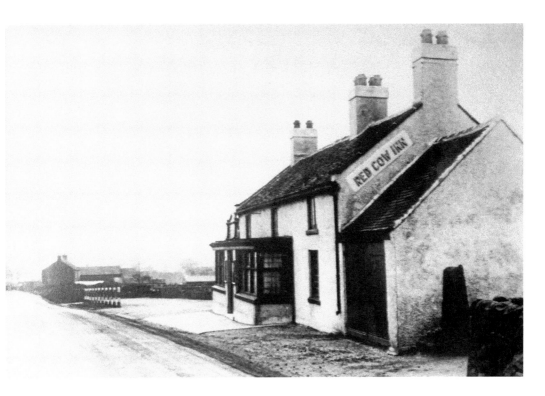

The Red Cow Inn, 1931 (from Werrington)

The Red Cow Inn is believed to date back at least until the early eighteenth century. There have apparently been few changes in the eighty-four years between the two photographs; the garage, the car park, the porch and the chimneys remain largely unchanged and even the embossed name sign has survived. The major differences are inside and at the rear where a large conservatory dining area has been constructed. The Red Cow is now a popular venue for eating out.

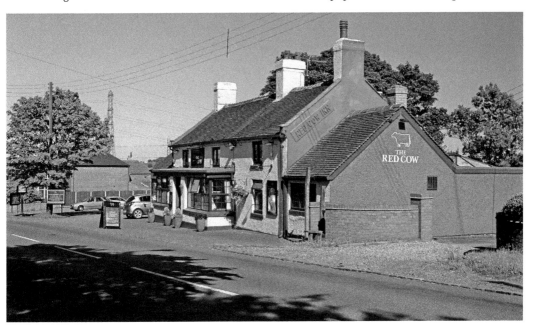

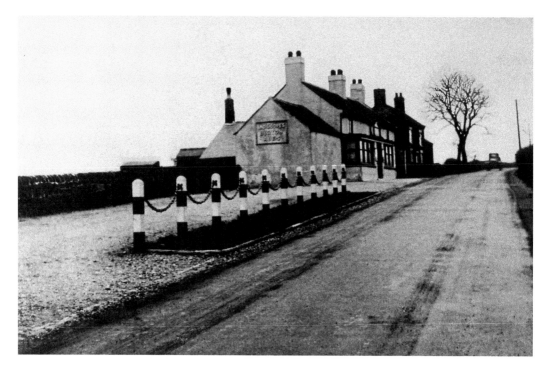

The Red Cow inn, 1931 (from Cellarhead)

In this photo of The Red Cow, taken from the direction of Cellarhead, the pub appears quite isolated from other buildings, apart from the house immediately to its right. Today that house has gone but there are new houses on both sides of the pub and also on the opposite side of the road, where they stretch almost all the way from Werrington to Cellarhead. There is now an almost constant stream of traffic travelling in both directions past the pub.

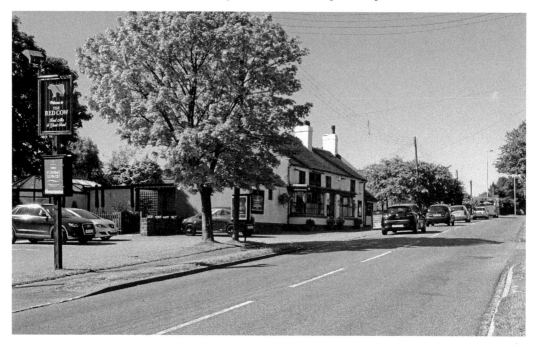

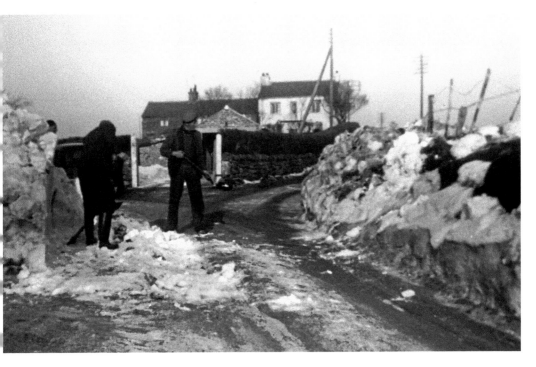

Junction of Armshead Road and Draw-Well Lane, 1950s

In this 1950s photo Armshead Road is being 'ridded' of snow near its junction with Draw-Well Lane. As shown on page 73, Draw-Well Lane begins on Ash Bank Road near the site of the old post office. It ends on Armshead Road, but the majority of the original course of the lane has been obliterated by the large housing developments that cover the area and have resulted in Werrington's population growing to more than five and a half thousand people since the 1950s.

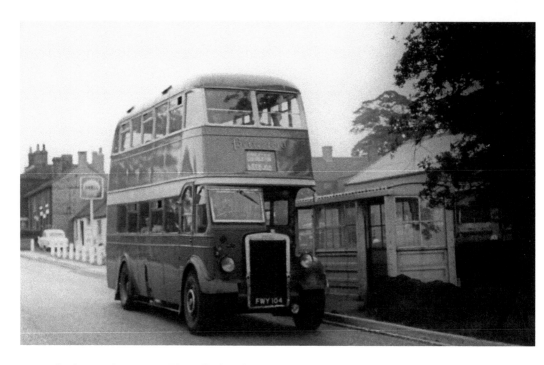

Berresford Motor's Bus Outside Cellarhead Garage, c. 1962

In this photo a Berresford's 1947 Leyland Titan PD1 double-decker bus is waiting at the stop outside Cellarhead Garage. It had come from Leek en route to Hanley via Cheddleton, Wetley Rocks and Cellarhead. Berresford Motors were based at Windy Arbour, Cheddleton now the site of Pointon's Park. This bus operated in Berresford's livery 1958–1964 so the photo dates from that period. Its disposal is given as 'unknown' so it may have been cannibalised or simply left to rot behind the garage.

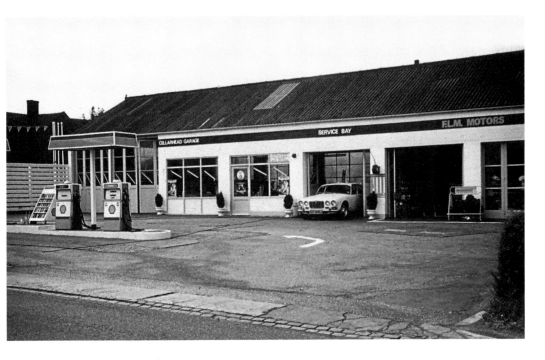

FLM Motors Cellarhead Garage

Cellarhead Garage was opened prior to 1964. In this, the earlier of the two FLM Motors photos (later overleaf), as well as doing repairs the garage was also selling Shell petrol and diesel. Later, as competition in fuel pricing became much fiercer, small garages were no longer able to compete with larger outlets who could command greater discounts and so most independent garages drained their tanks and removed the pumps. This decline in the number of independent petrol stations continues and is now nearly complete.

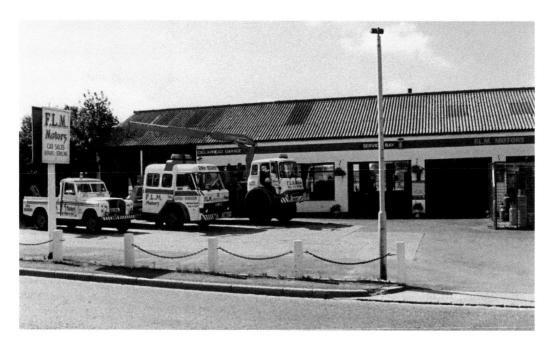

FLM Motors Cellarhead Garage

In this later photo of Cellarhead Garage, the fuel pumps have been removed and there is a fleet of FLM recovery vehicles parked outside, including a Land Rover Defender, the last one of which rolled off the production line on the day this caption was written. These vehicles were used as part of a contract for recovering broken-down or damaged police vehicles. The roadside sign announces that the garage handles car sales, repairs and servicing.

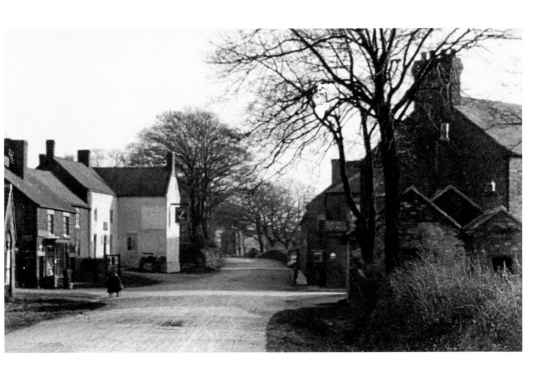

Cellarhead Crossroads, 1925

Cellarhead crossroads was an important meeting place and on 5 May and 5 November each year fairs were held there. Bull- and bear-baiting apparently took place behind the building in the centre left. By 1800 both roads had been turn-piked and inns developed on each corner: the Red Lion, the Spotted Cow (later the Bowling Green), the Hope & Anchor and the Royal Oak. In 1905 all four remained open but the last of them, the Bowling Green, has now closed, replaced by Sub-4 Health Centre.

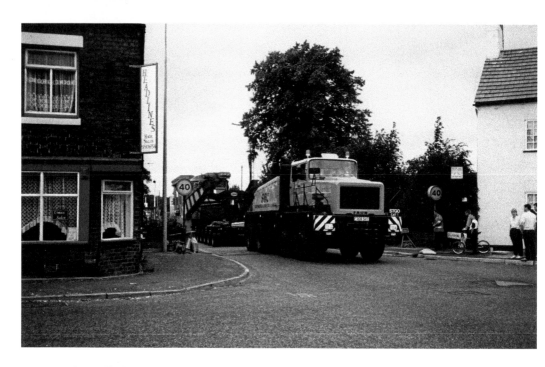

Long Load at Cellarhead Crossroads

This outsized vehicle bears the name GEC Distribution Services (later GEC Alsthom and now simply Alstom). It appears to be carrying a huge electrical transformer. The movement of such enormous items is seldom without problems and where they occur regularly, road alterations, such as gated roads across roundabouts are sometimes made to facilitate them. In the case of this delivery, the traffic lights needed to be temporarily removed to allow the vehicle to manoeuvre around the corner.

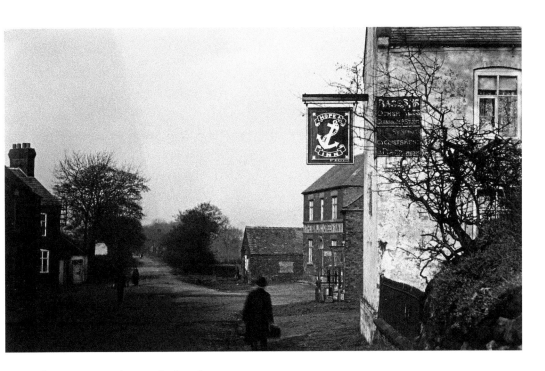

The Hope & Anchor, Cellarhead

In the foreground is the Hope & Anchor and on the other side of Kingsley Road, the Bowling Green Inn. The proprietor of the Hope & Anchor at this time was J. Plant. On the near side of Cellarhead Road, on what is known to have been the Royal Oak, there is a sign resembling a 'Hanging Gate' – was this perhaps its name for a time? This same sign is visible on page 91 next to the sign for Bunting's Ales.

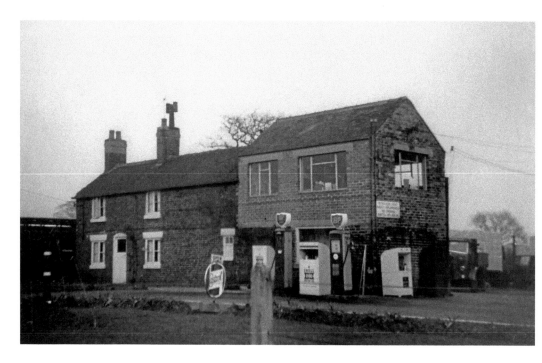

Shirley's Transport Ltd, Cellarhead

Shirley's Transport was founded by James Shirley in 1936 and was originally based in Rownall, where it was mainly concerned with the movement of livestock. In 1943 Mr Shirley bought Mount Pleasant Farm at Cellarhead and moved his depot to the new premises, later named Mount Pleasant Garage. Here a large extension containing the office has been added to the original house. Later still the entire building was remodelled into its present form containing the offices, stores and a shop for fuel sales, etc.

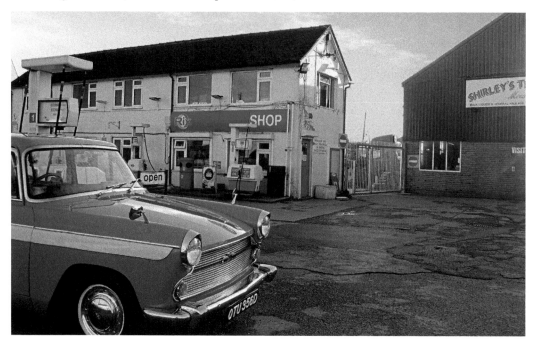

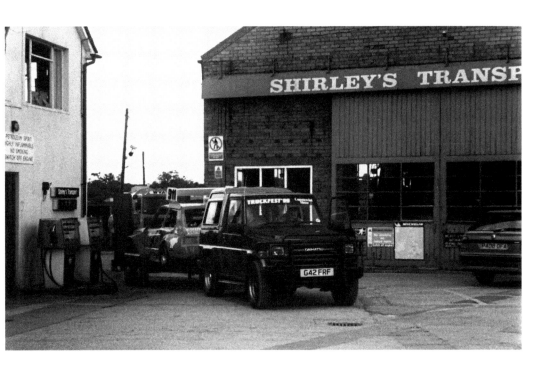

Shirley's Transport, Cellarhead

Once based at Mount Pleasant Garage the company moved away from livestock transport into general haulage and in the 1950s was contracted by several of the large Burton-on-Trent breweries. In 1966 Arthur Shirley, present head of the company, began driving Shirley's first tanker. Today the transportation of various liquids forms a major part of the company's business, although the company does also haul 'dry' goods as well. The company has vehicles based at various locations in Britain and makes deliveries throughout Western Europe.

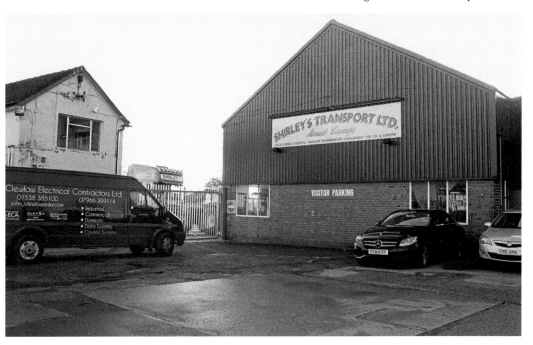

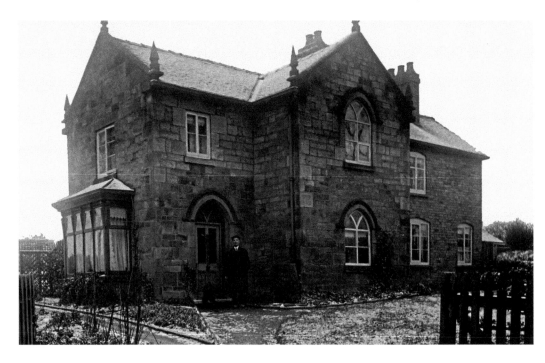

Southlow Cottage

This old photo shows Frederick George Payne standing proudly outside Southlow Cottage, which he had moved into between 1901 and 1911. The stone-built property already had a brick extension on the right and has more recently been extended again, as seen by comparing the photos. Mr Payne was a retired publican who had kept a pub at No. 59 Werrington Road in 1901. This unidentified pub would have stood between today's Great Wall takeaway and the block of older houses higher up the road.

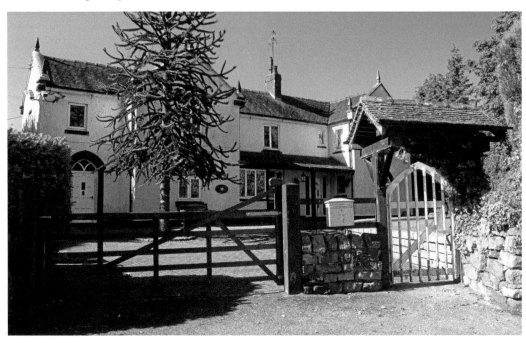